Whimsical Designs

Coloring for Artists

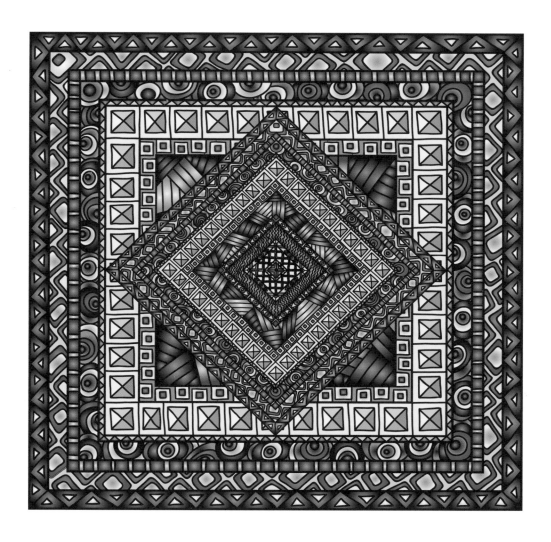

Skyhorse Publishing

Whimsical Designs: Coloring for Artists

The coloring books of our youth were often filled with whimsical art, be it fairies or gnomes. They offered us an escape to different worlds where we could let our imaginations run wild. But these coloring books were for kids. The designs were simple and gave even the most impatient child a chance to stay within the lines. The collection of whimsical art presented to you here is at the other end of the spectrum. While the designs range in complexity, they are all intricate examples of whimsical art created for adults of any skill set to color. Yet, they offer the same pleasure and escape that our childhood coloring books offered. In fact, this beautiful collection presented here is probably more beneficial to adults because it offers us a rare moment of relaxation, allowing us the opportunity to focus only on the whimsical image coming to life on the page. The exercise of coloring is also a healthy and creative medium that permits adults to express their feelings, similar to keeping a journal, and whimsical art is a great way to express yourself.

Whimsical art is a vibrant and playful style of art that is carefree and childlike. Commonly, it is associated with children's book illustrations and fairy tale art. It is artwork that often strives to lift the spirit and make you happy. Whimsical art is characteristically (but not necessarily) bright, colorful, and fun. But it doesn't always have to be sweet and darling. Art imbued with whimsicality can also include the scary, the strange, and the ugly. For example, Tim Burton's cast of characters in *The Nightmare Before Christmas* are a dark group of mostly loveable whimsical characters that emerge

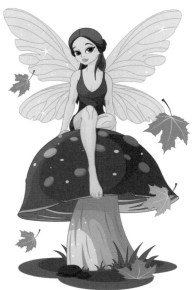

A whimsical fairy that exemplifies the magical worlds created in whimsical art.

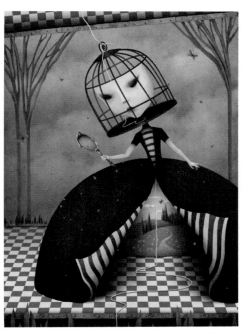

The darker side of whimsical art and where the imagination can lead.

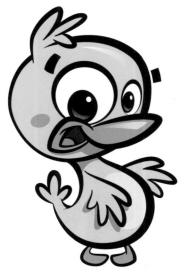

A whimsical duck reminiscent of characters we colored as kids.

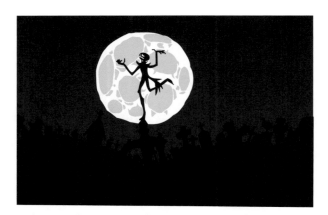

The Nightmare Before Christmas is a great example of the stranger and scarier side of whimsical art.

from the darker side of human psychology. Such characters express innocence gone awry. They represent the shadowy side of whimsicality. In the world of the whimsical, imagination rules supreme. Whimsical worlds envelop the realms of mystery and magic, where the surreal is more real than unreal. Such art has the power to take us to other places and to plumb the depths of our most hidden dreams. There is an innocent poetry to whimsical art. It can tell tales, or it can leave the story-telling up to the viewer. Either way, whimsical art delights and enchants, weaving a charming and spirited path through our imaginations.

This book offers a fantastical collection of whimsical designs for you to color, allowing you to explore your creative and artistic sides. The designs vary from relatively simple to complex, giving you the opportunity to improve your technique and test the limits of your creativity. The whimsical style allows for a wide range of designs and images, so this book definitely has pieces that will inspire your creative genius.

The designs are printed on only one side of the page, and the pages are each perforated so they can be removed from the book to make coloring easier (as well as to allow you to use them as decoration). There are also colored examples of each of the designs in the front of the book, which can give you some ideas and inspiration on color palettes and how to use them. The fun of coloring, though, is to use your own colors and outside inspirations. So enjoy and see just how whimsical you can be!

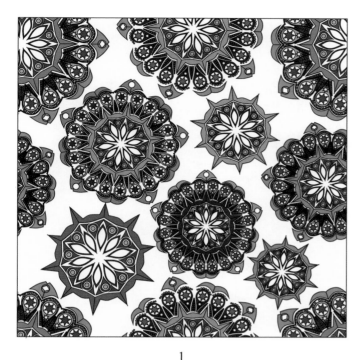

1

2

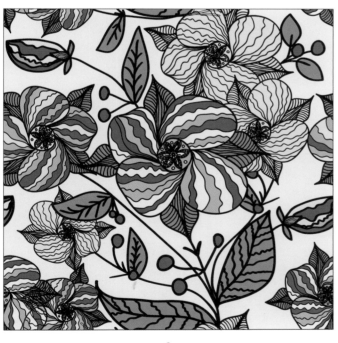

3

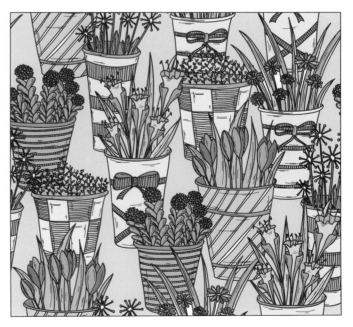

4

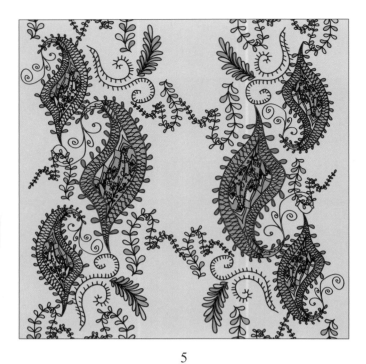

5

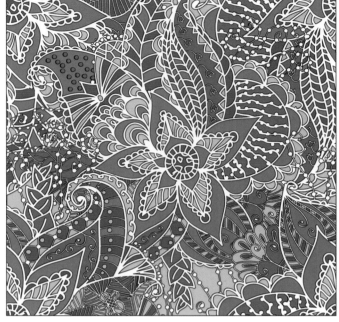

6

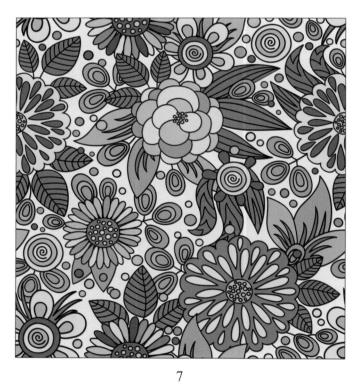

7

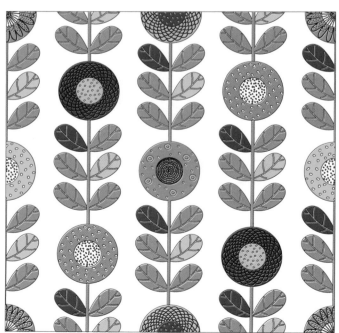

8

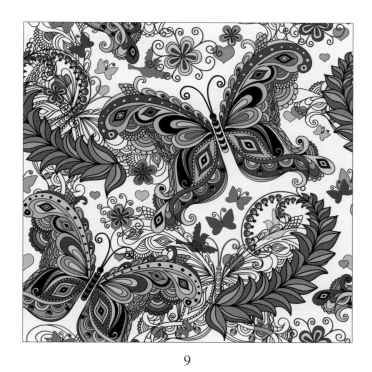

9

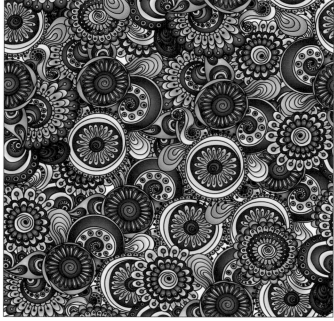

10

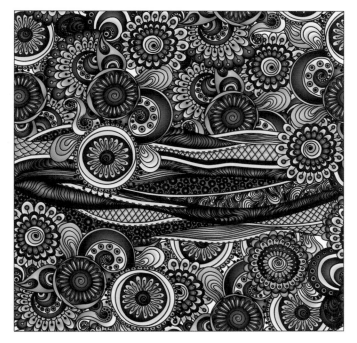

11

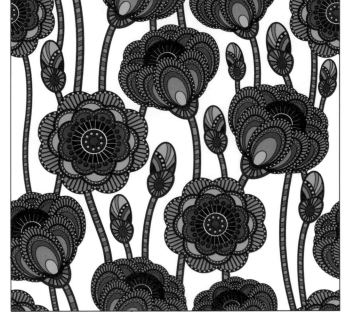

12

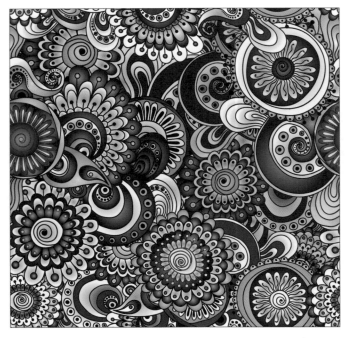

13

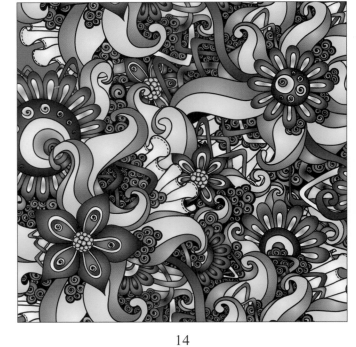

14

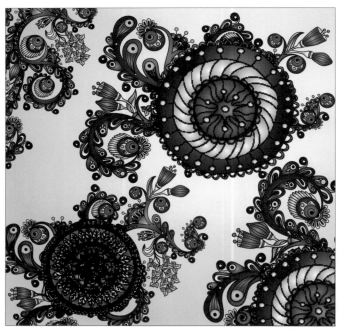

15

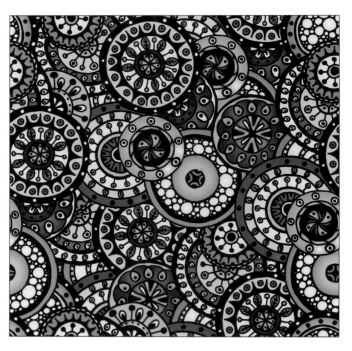

16

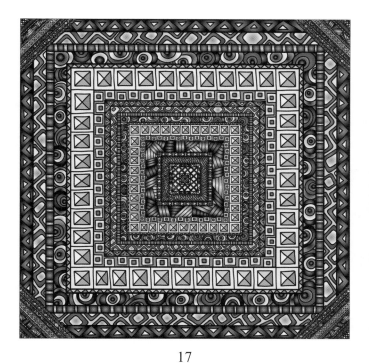

17

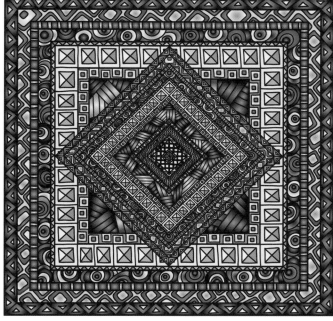

18

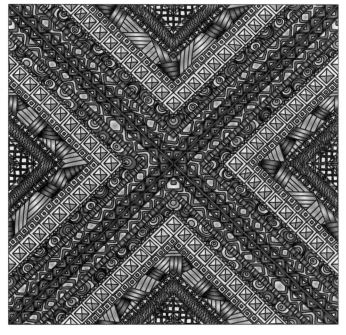

19

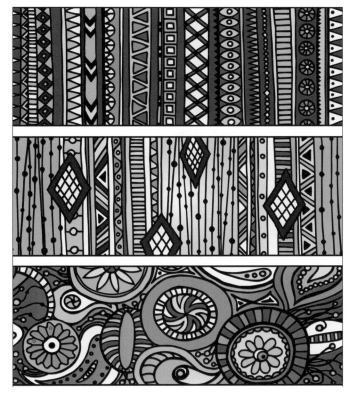

20

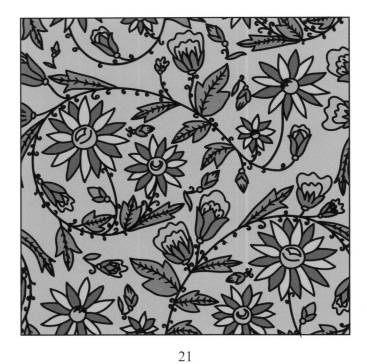

21

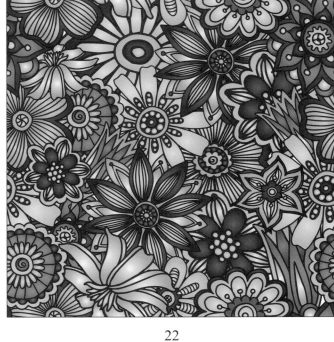

22

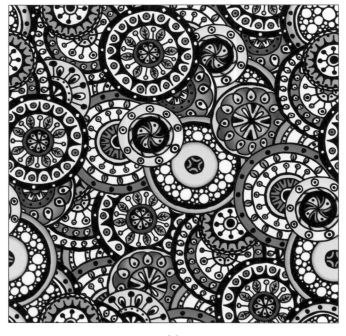

23

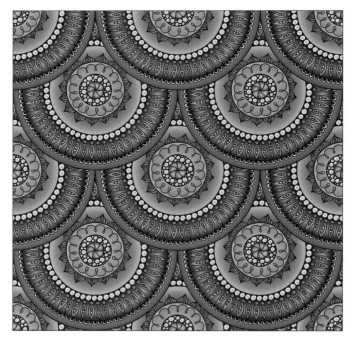

24

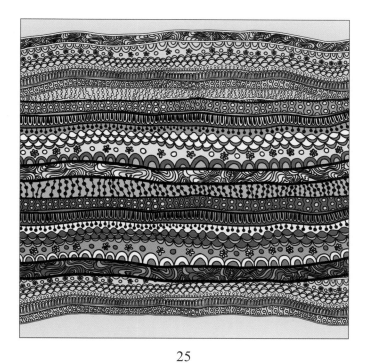

25

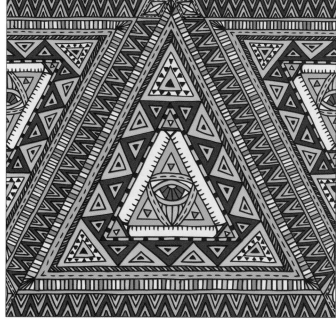

26

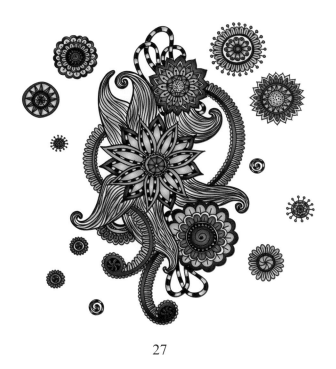

27

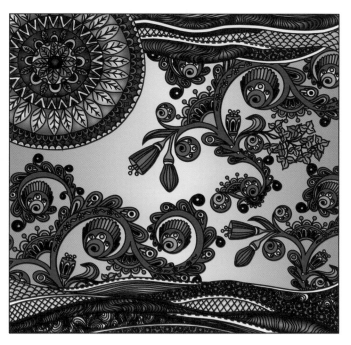

28

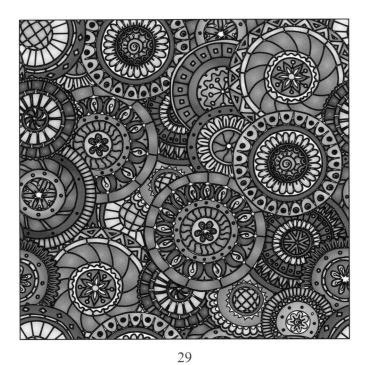

29

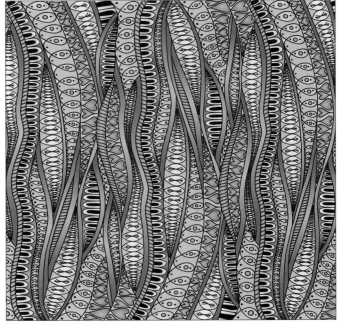

30

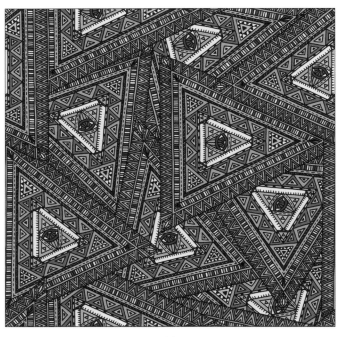

31

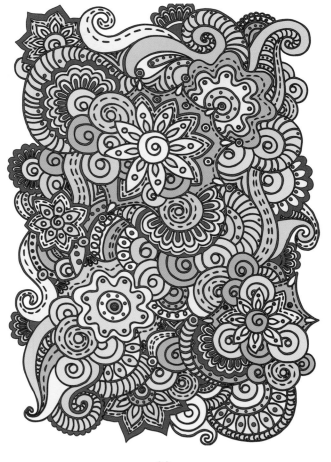

32

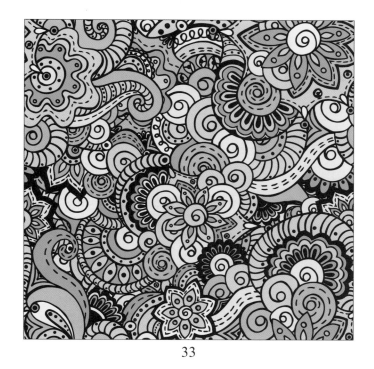

33

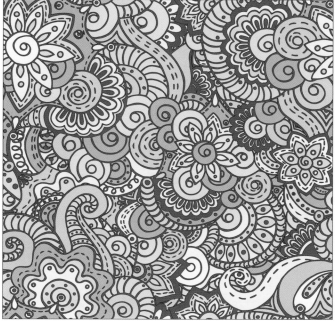

34

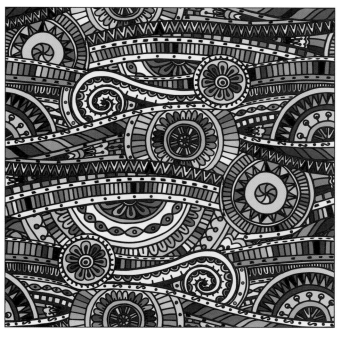

35

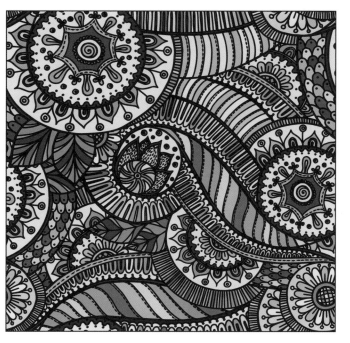

36

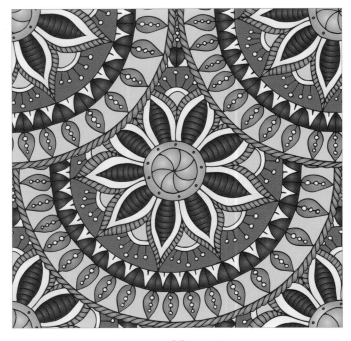

37

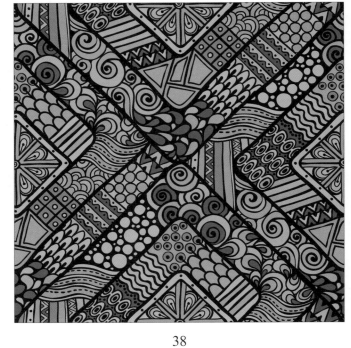

38

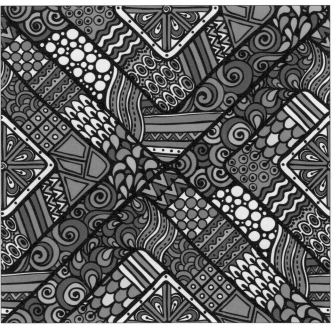

39

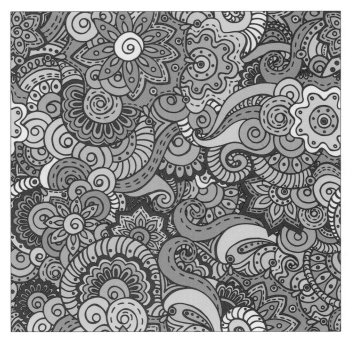

40

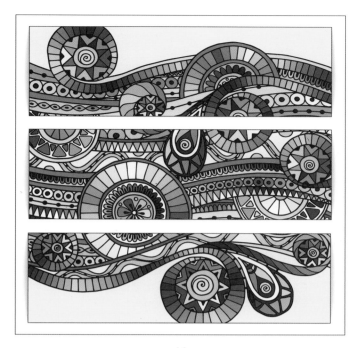

41

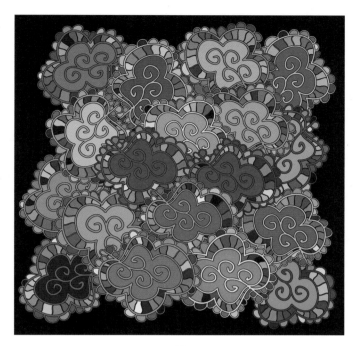

42

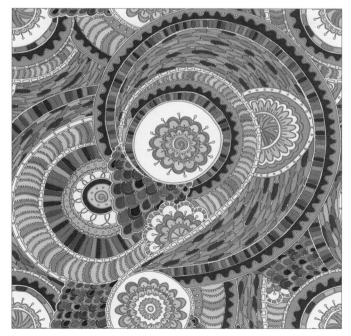

43

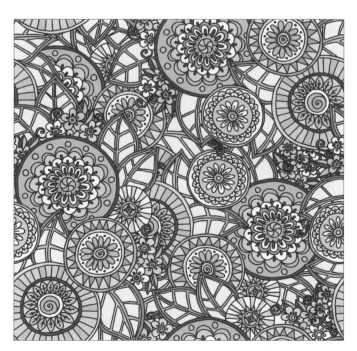

44

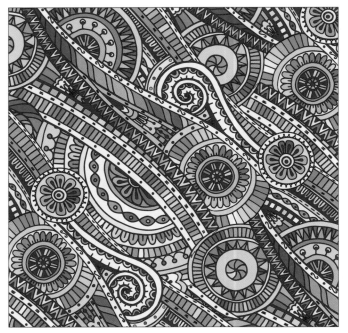

45

46

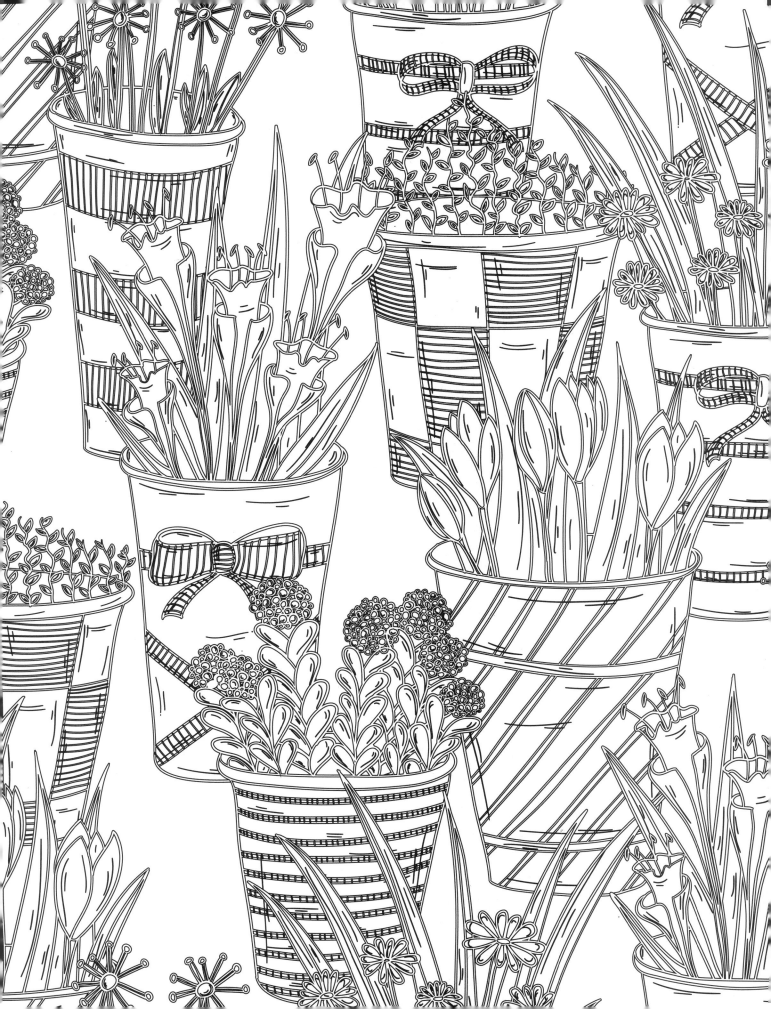

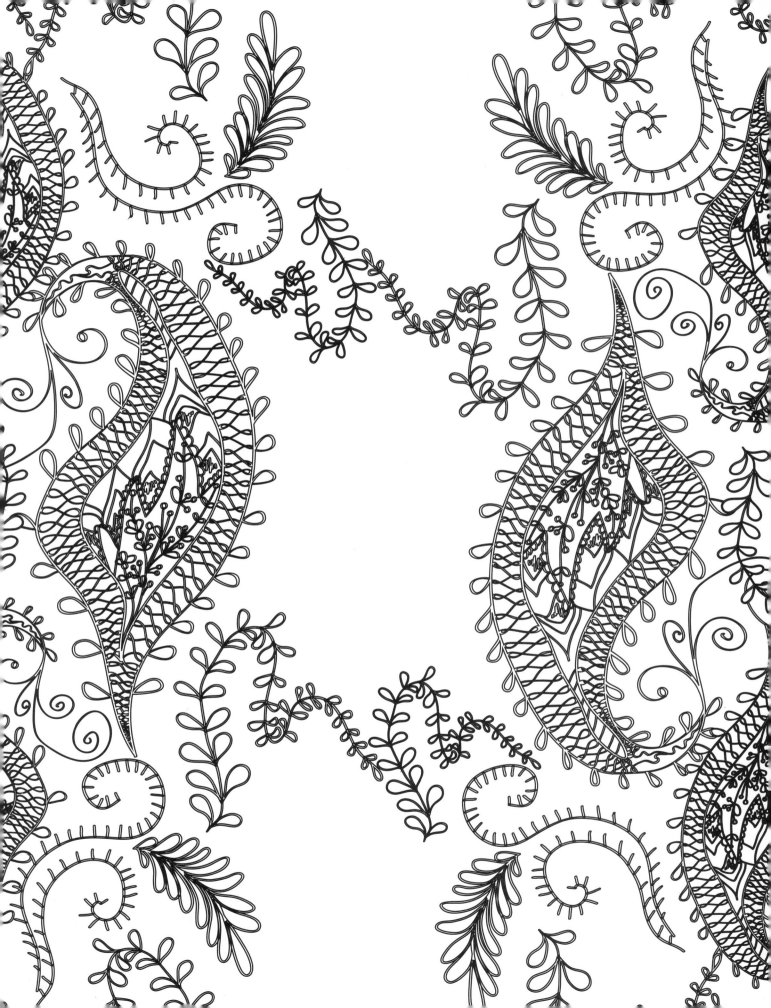

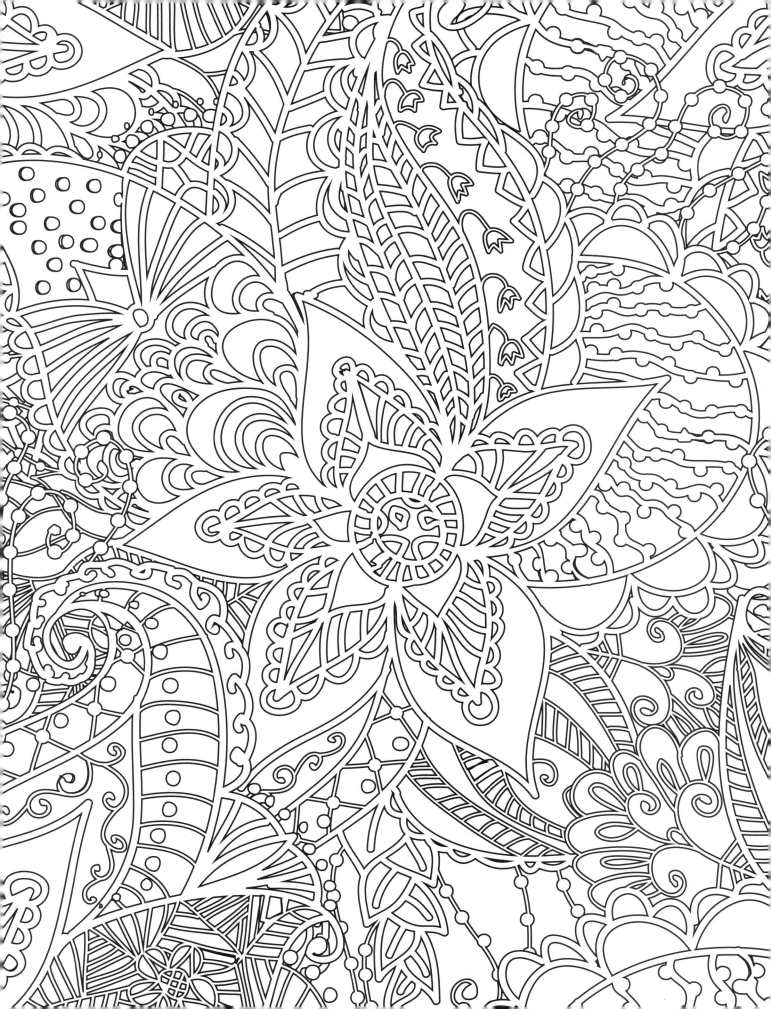

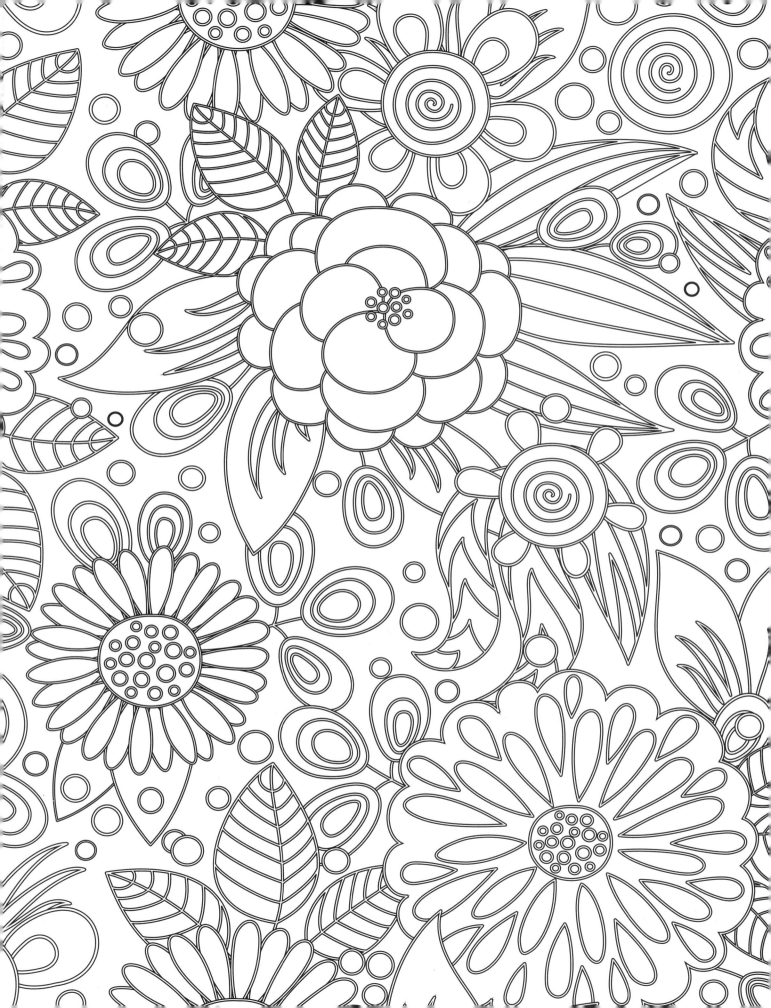

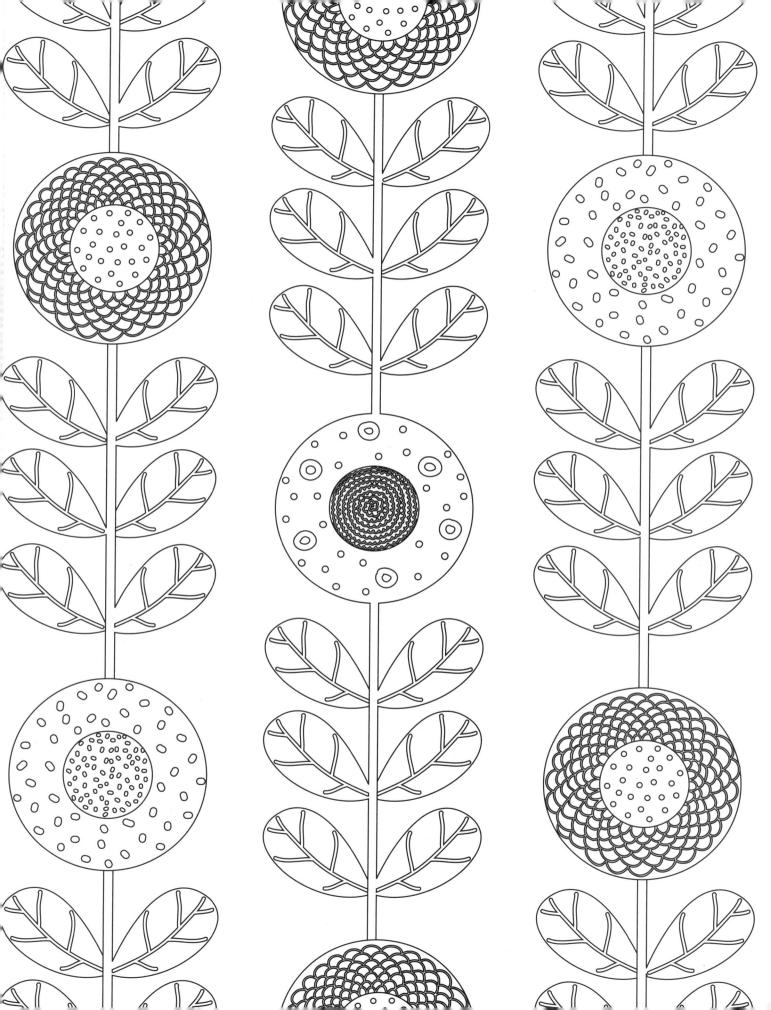

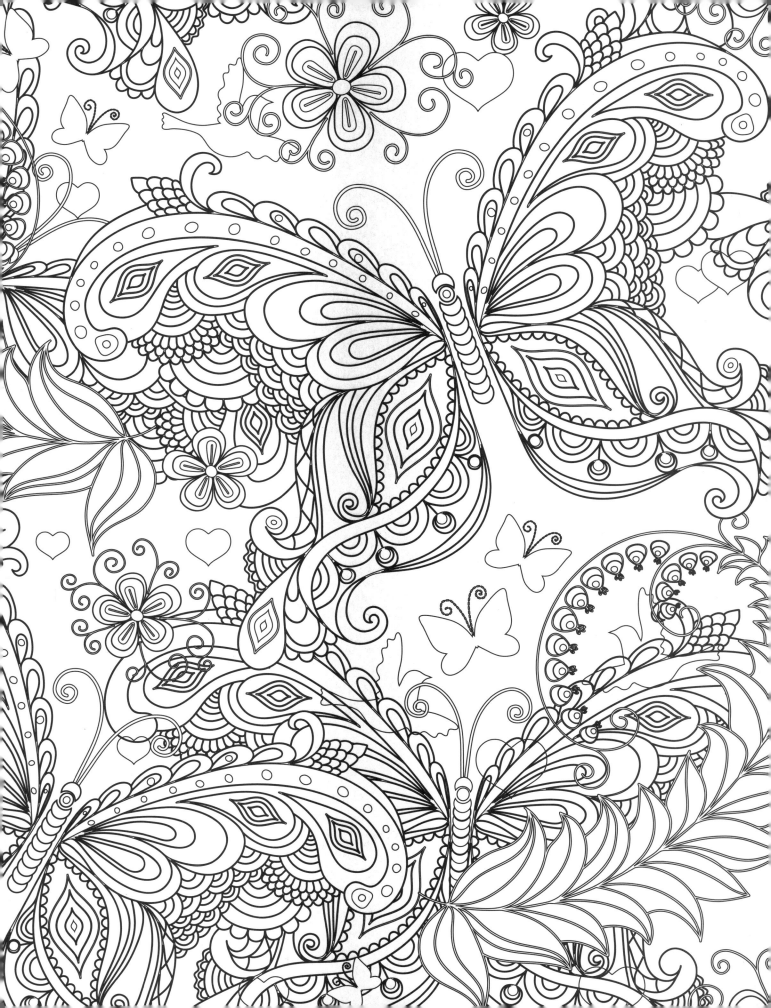

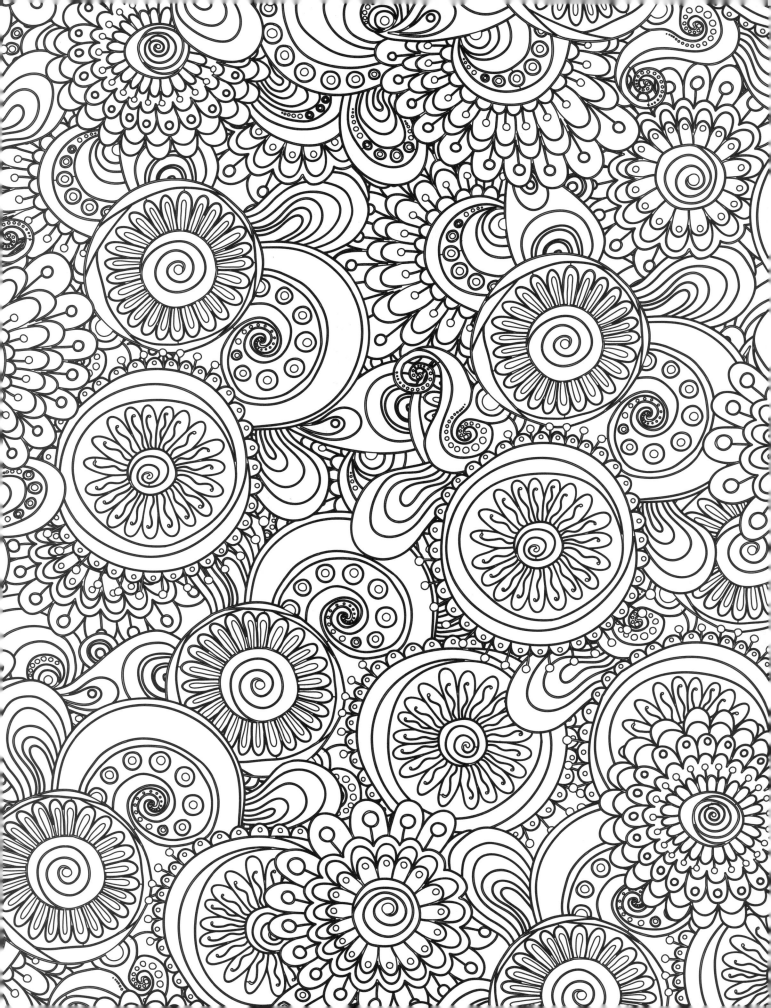

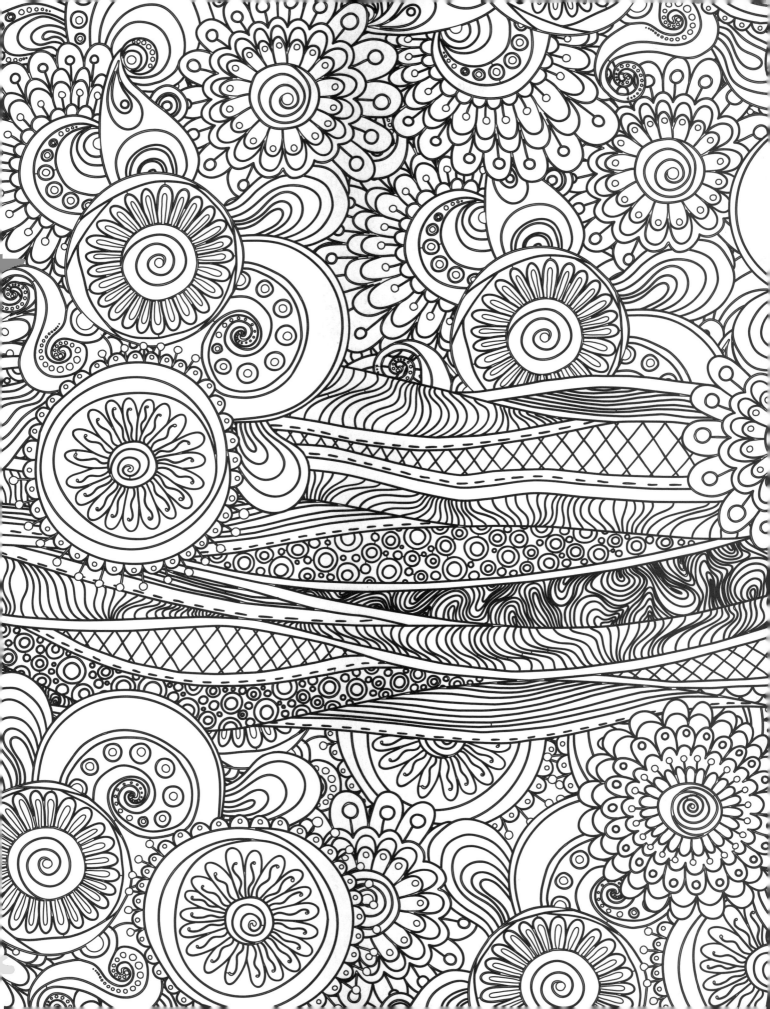

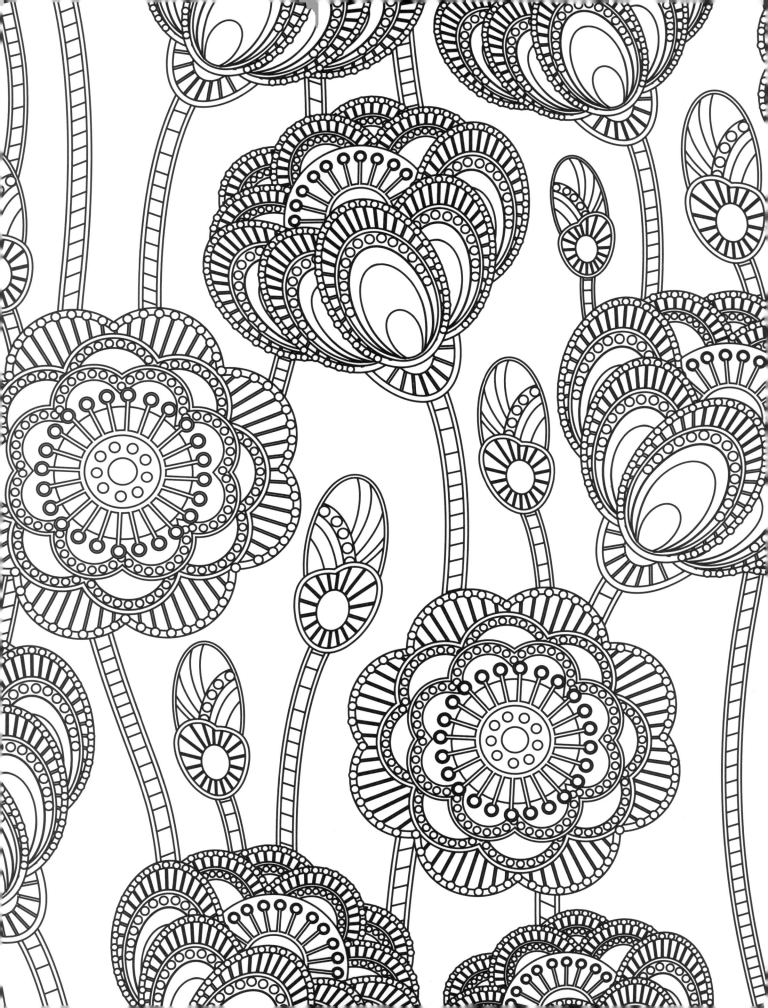

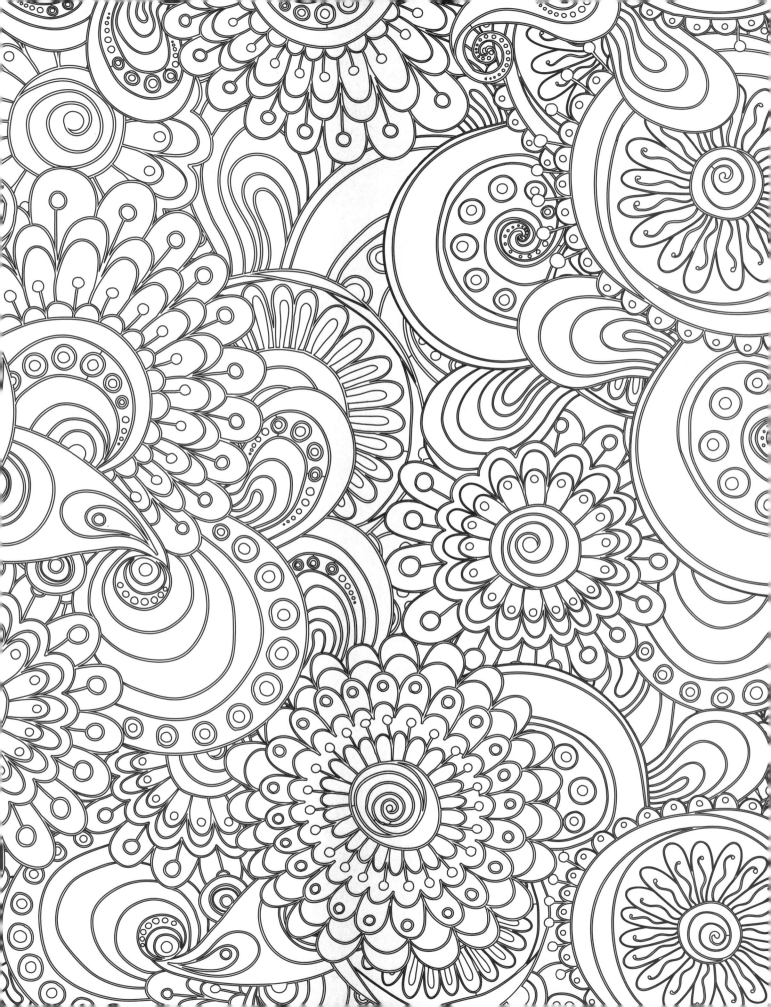

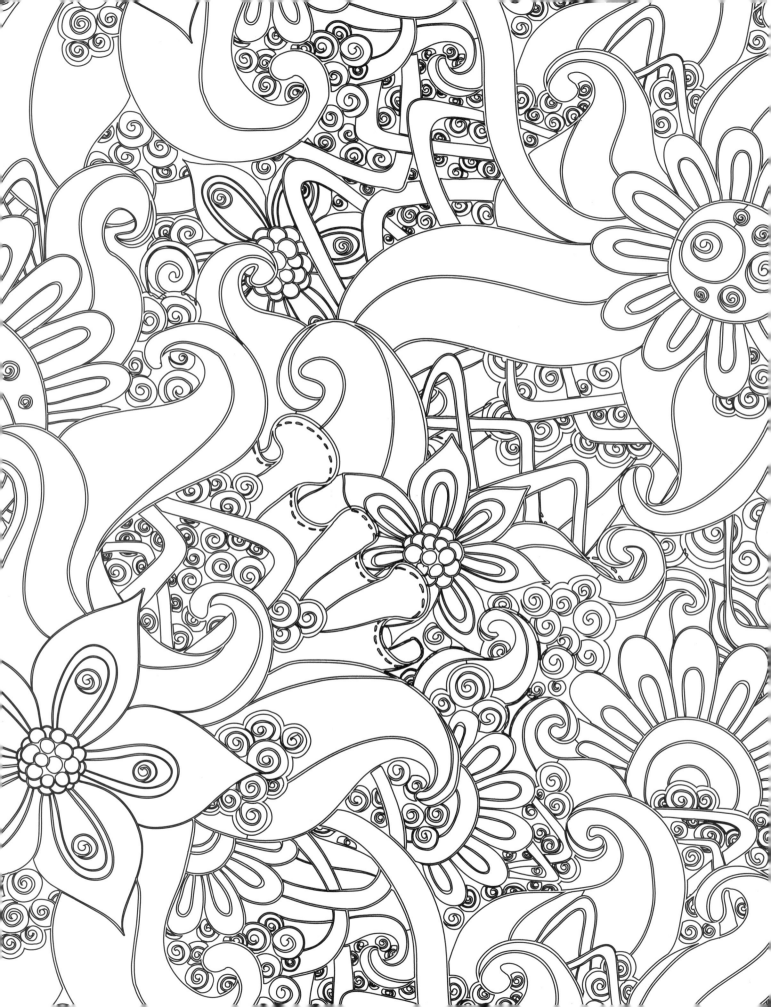

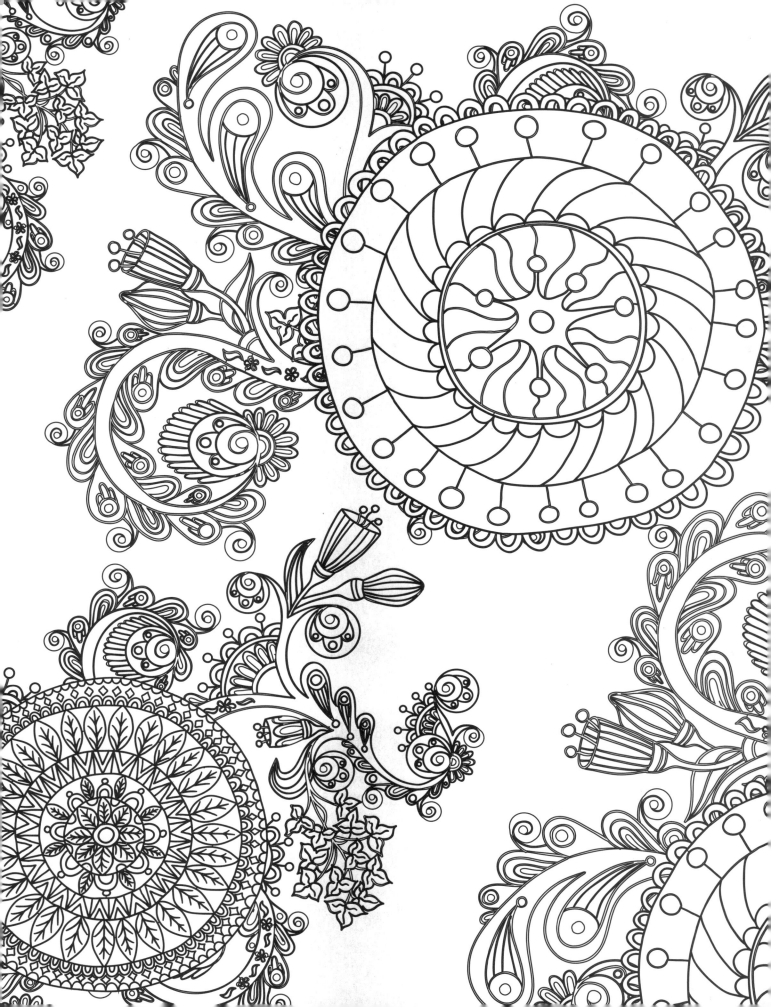

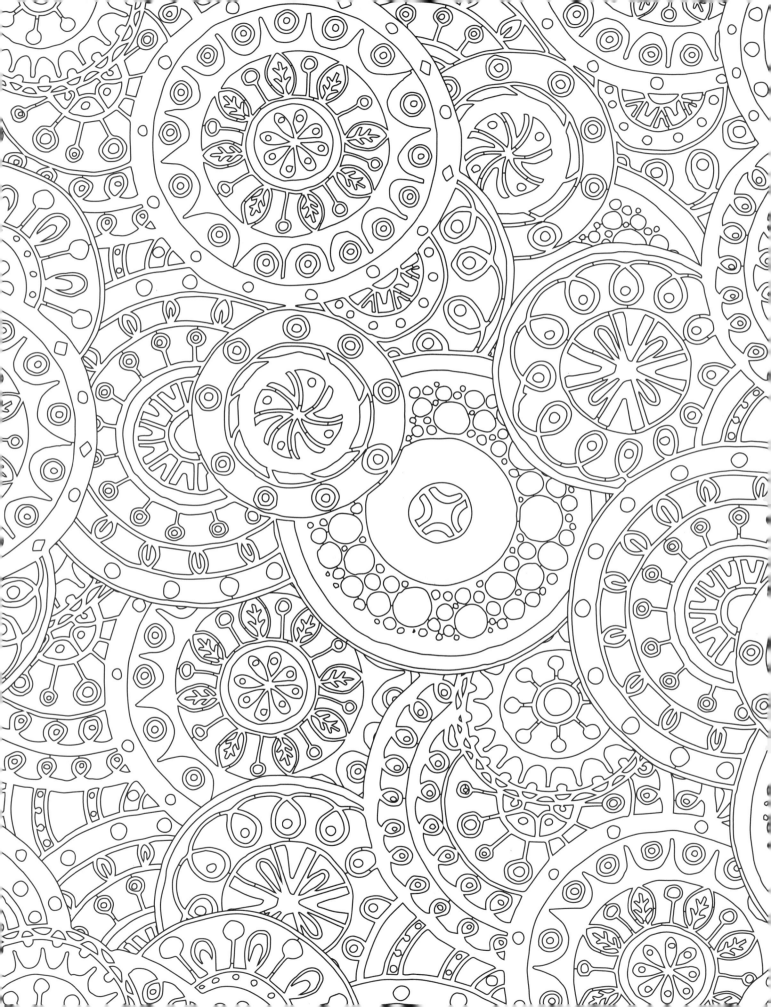

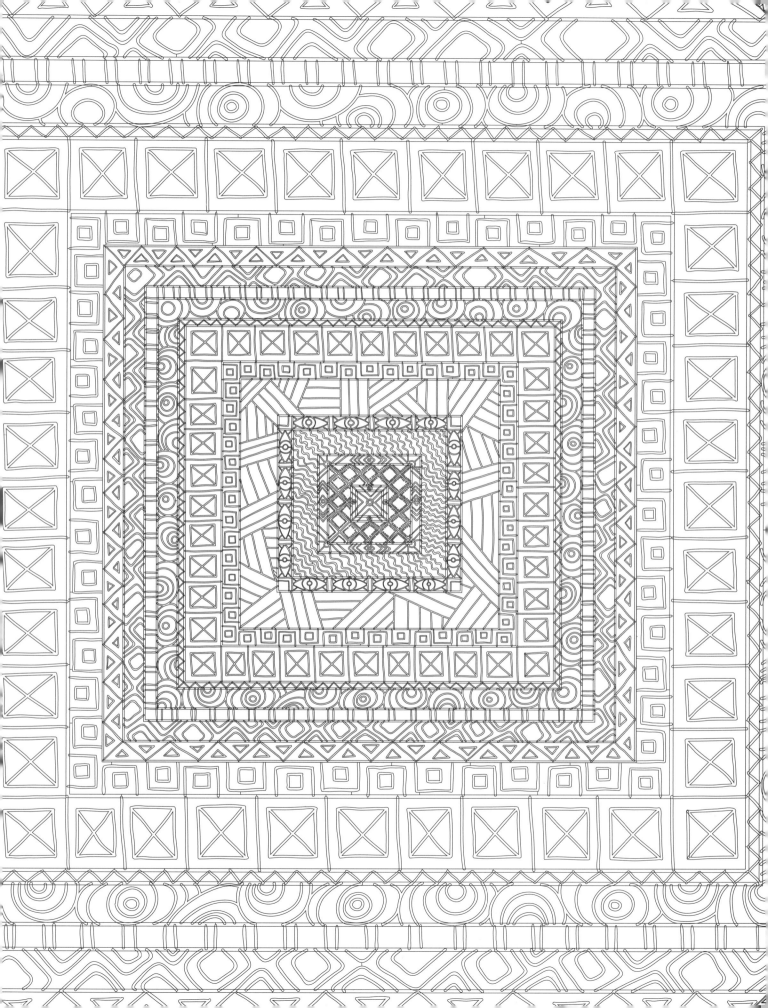

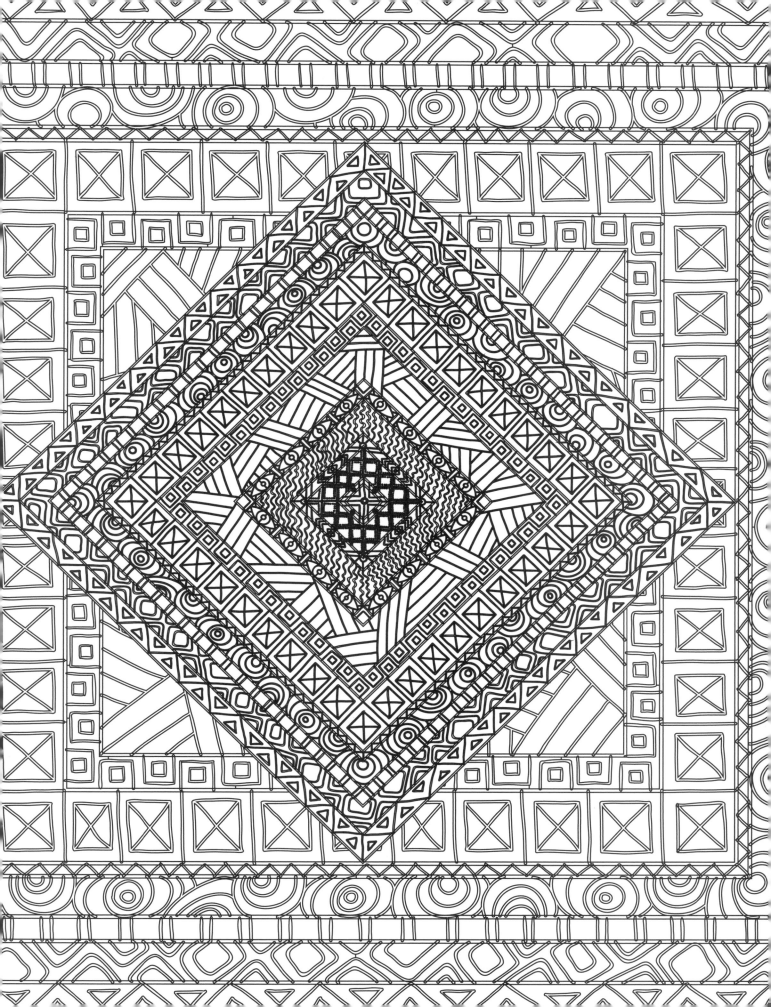

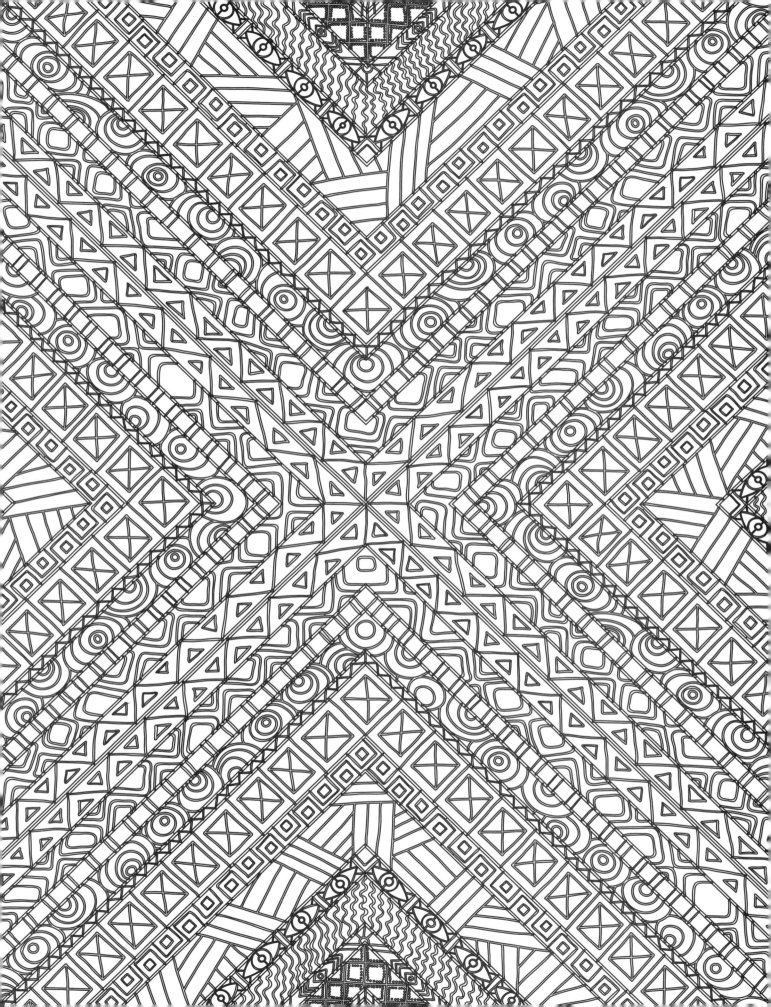

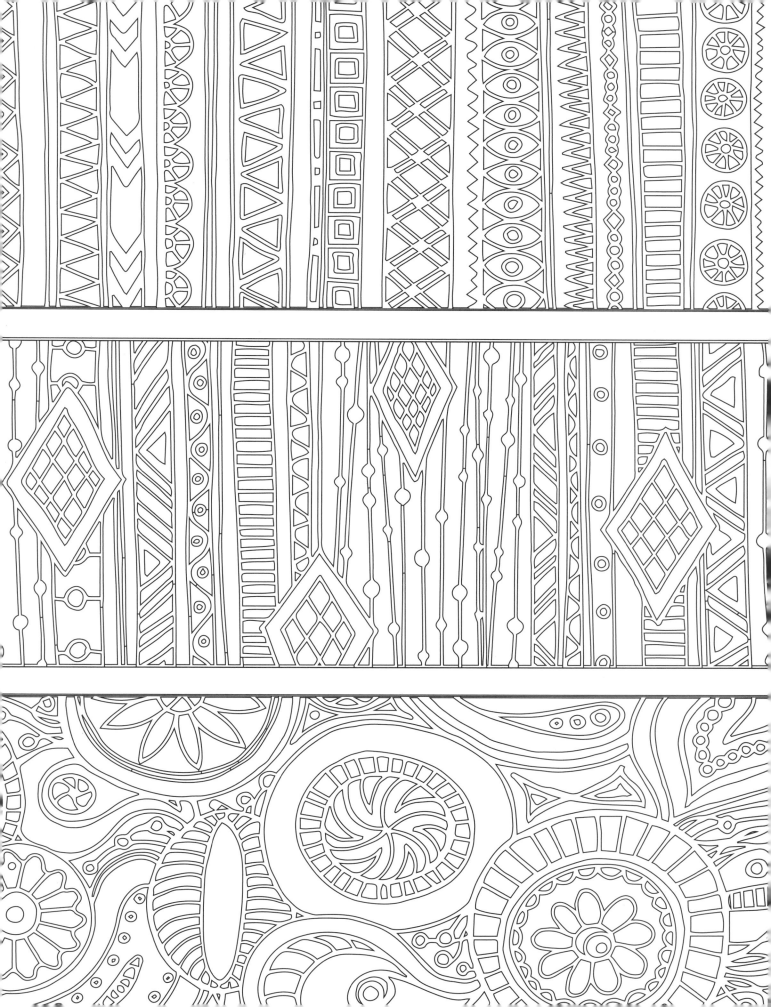

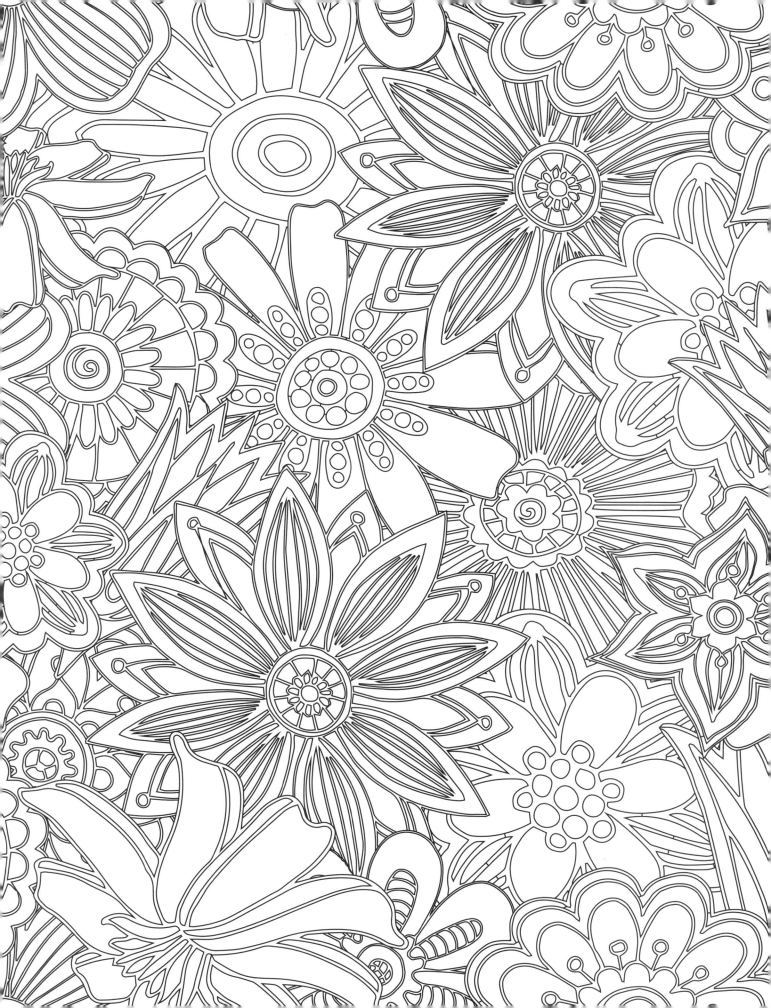

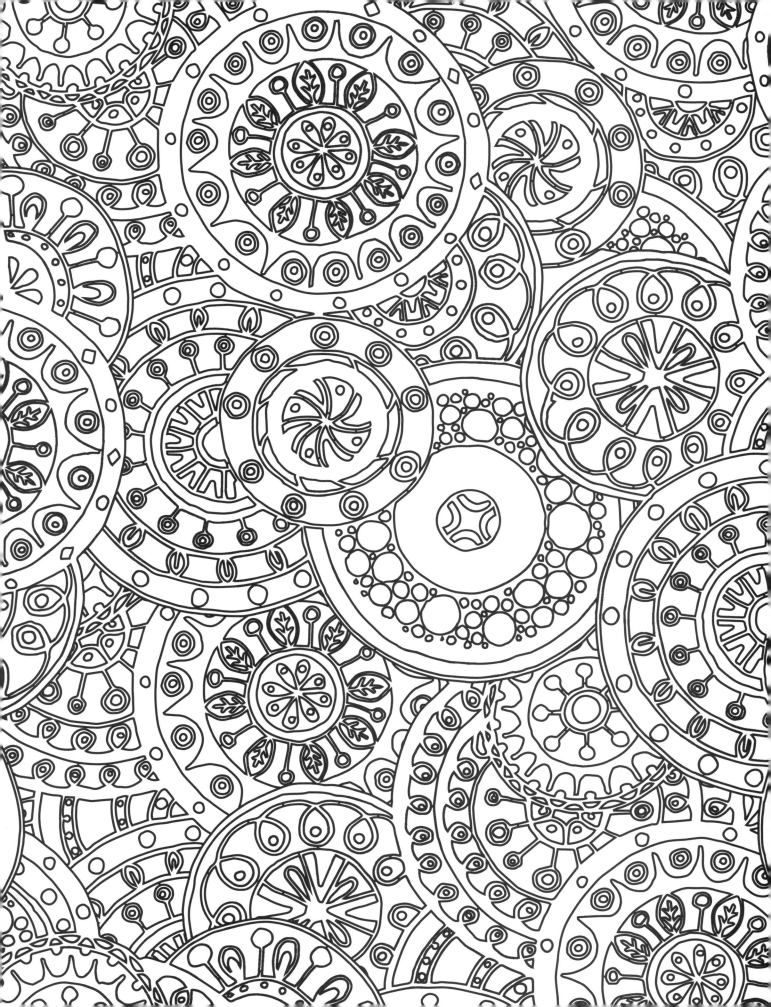

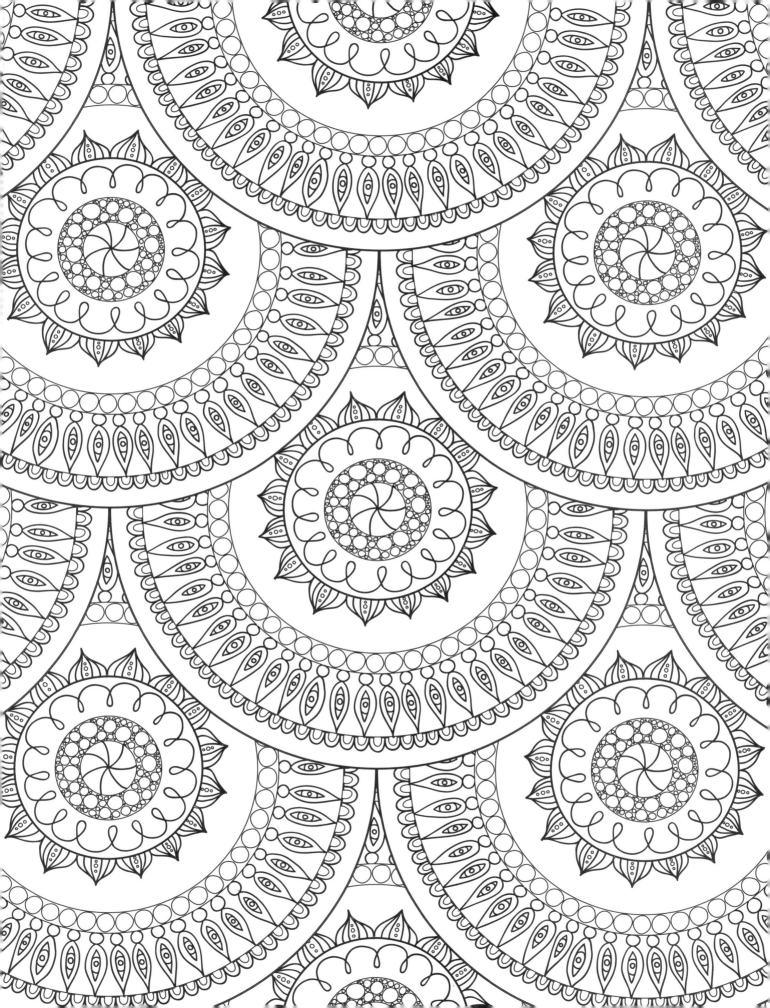

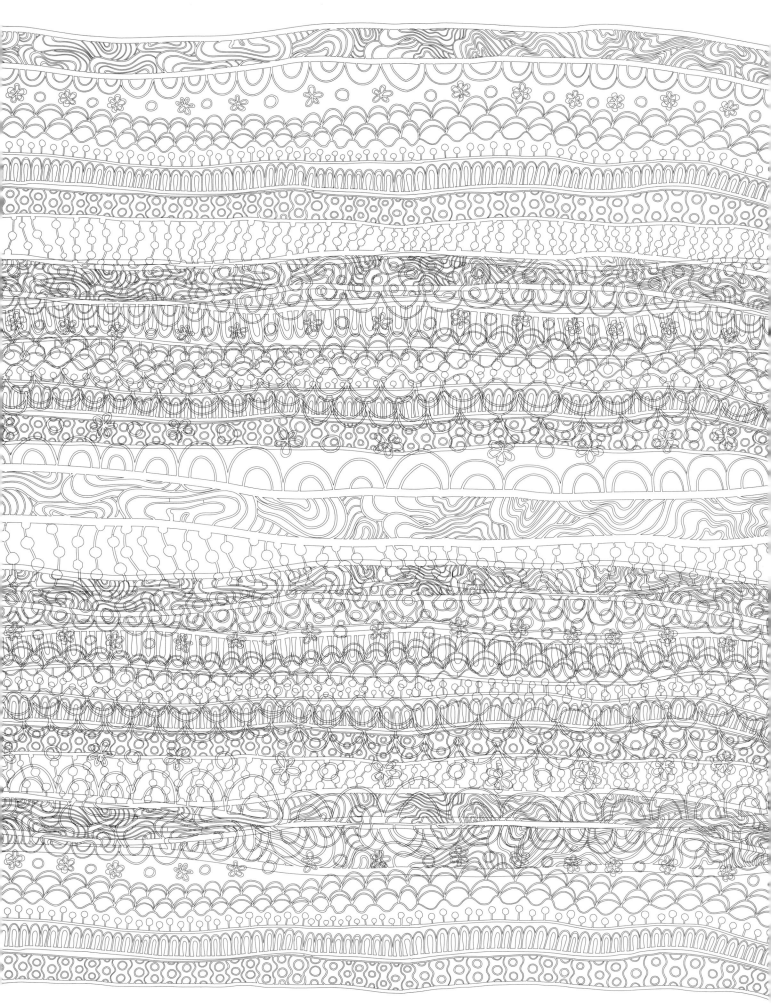

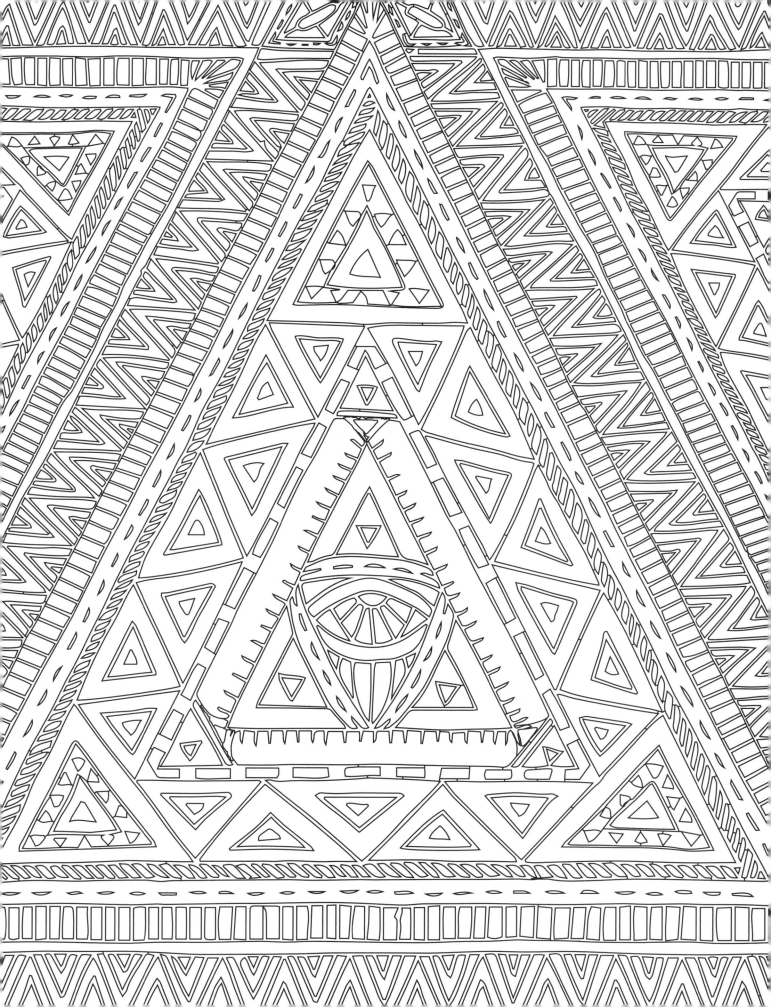

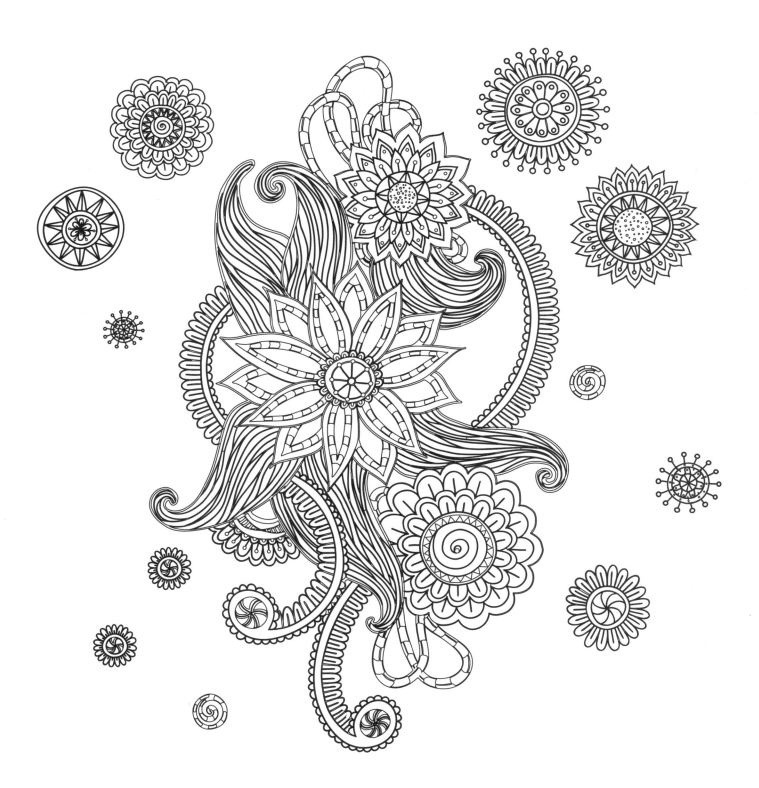

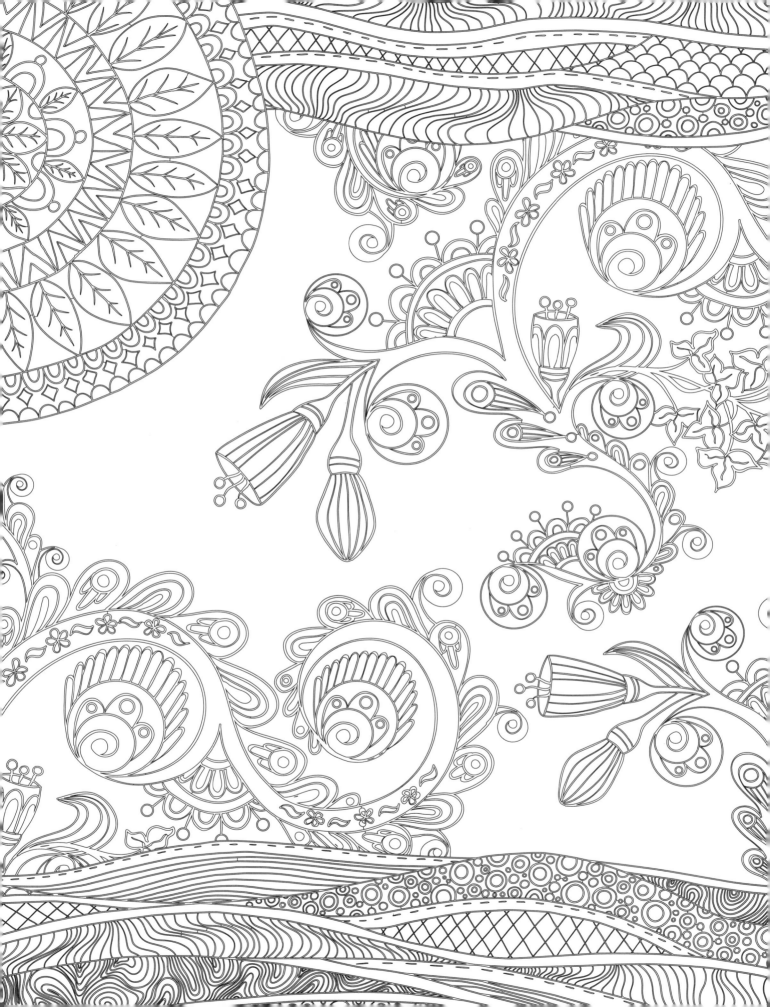

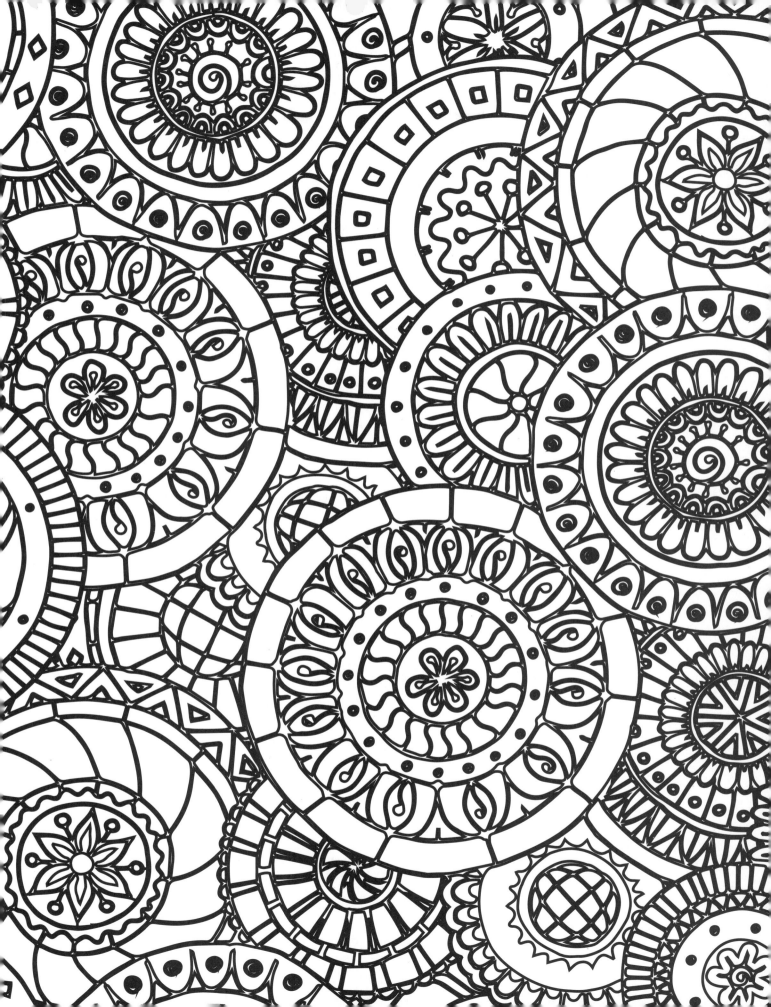

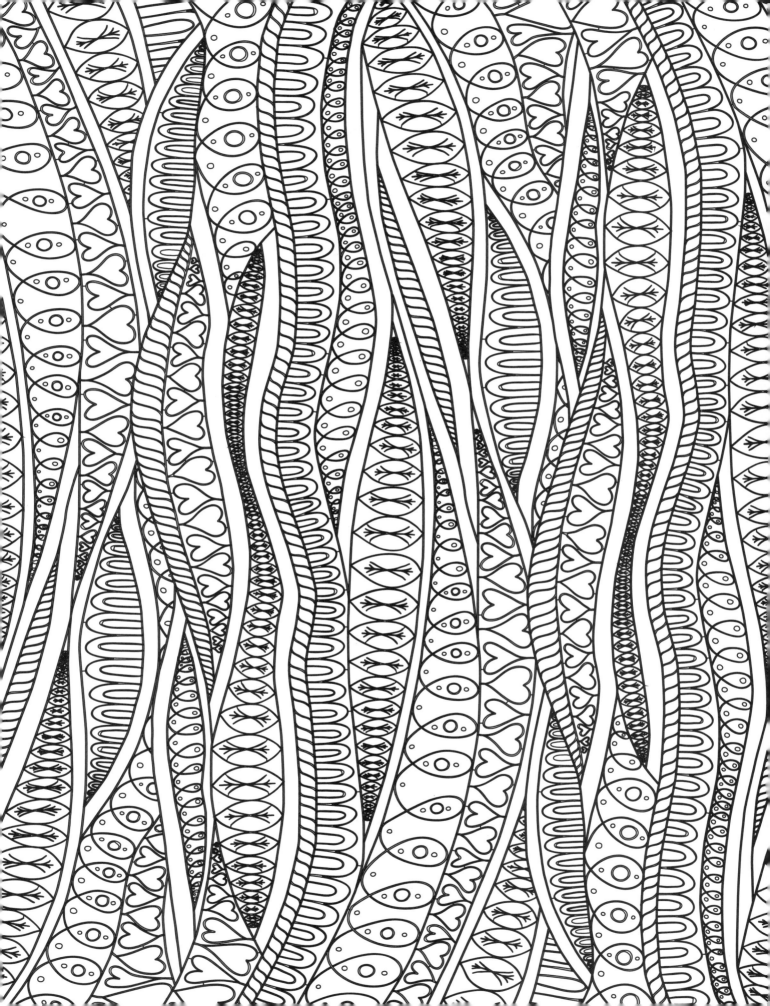

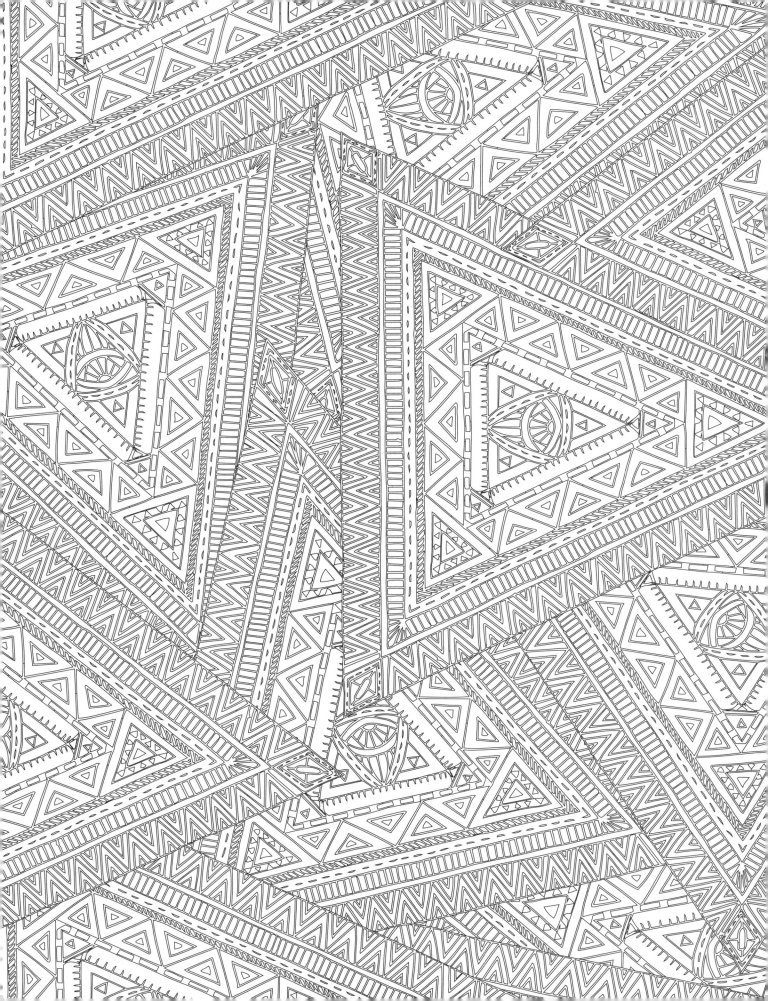

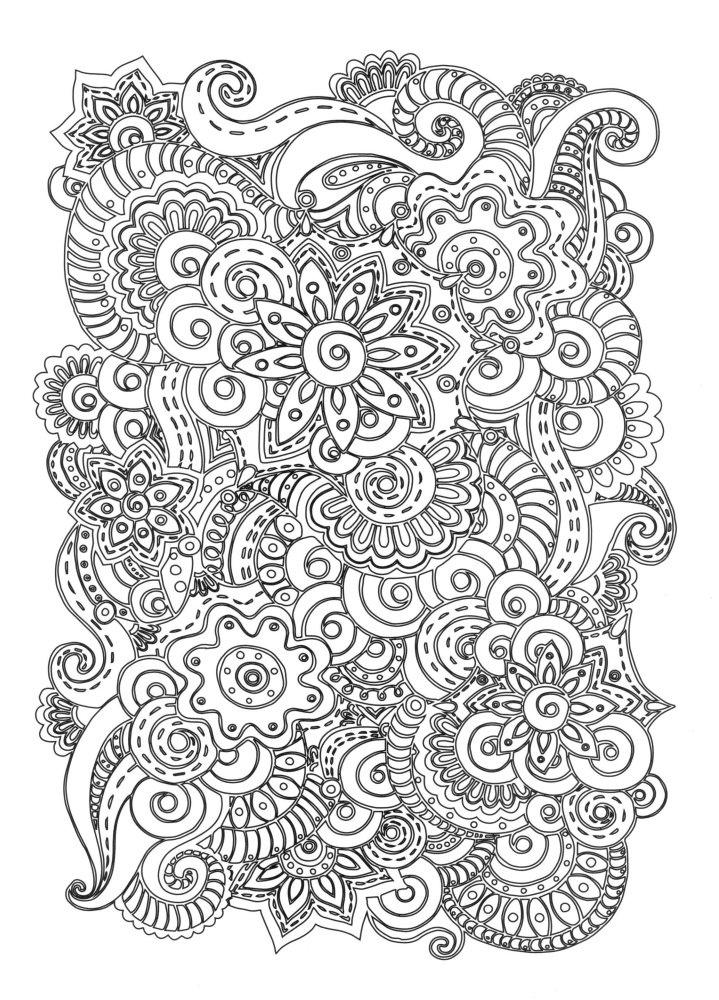

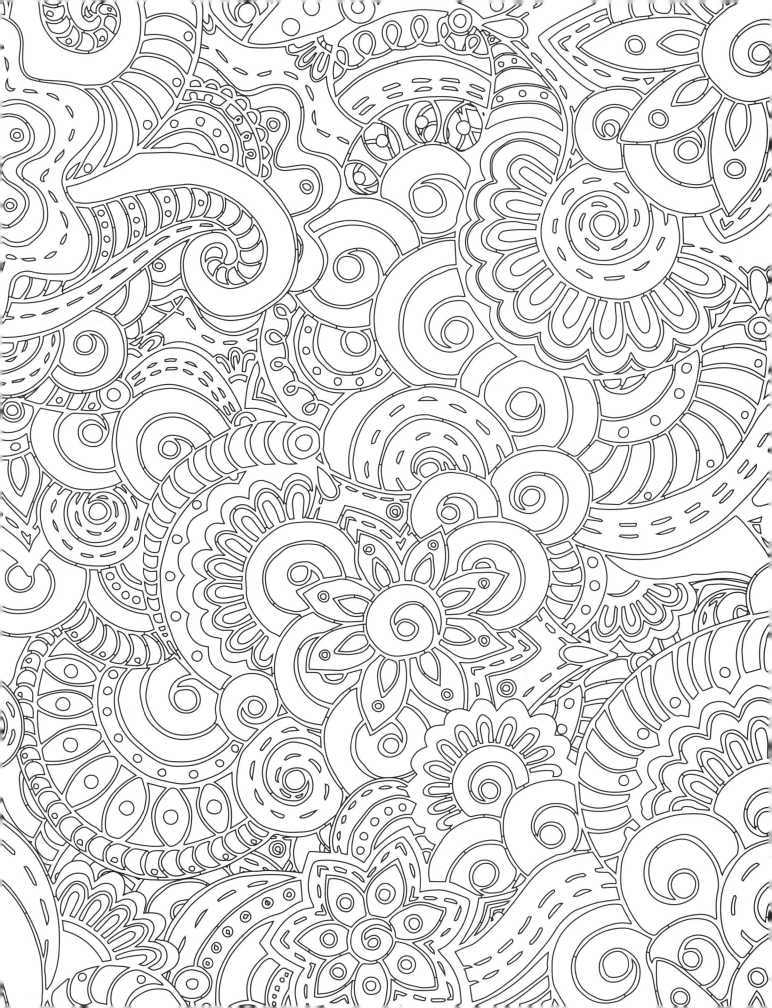

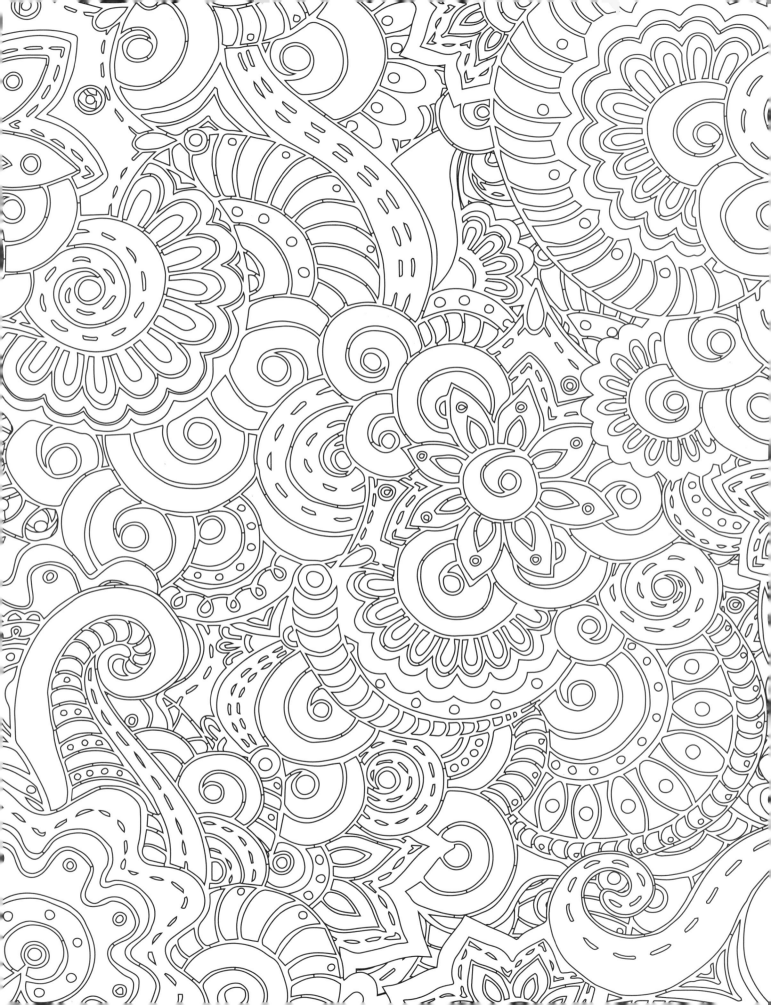

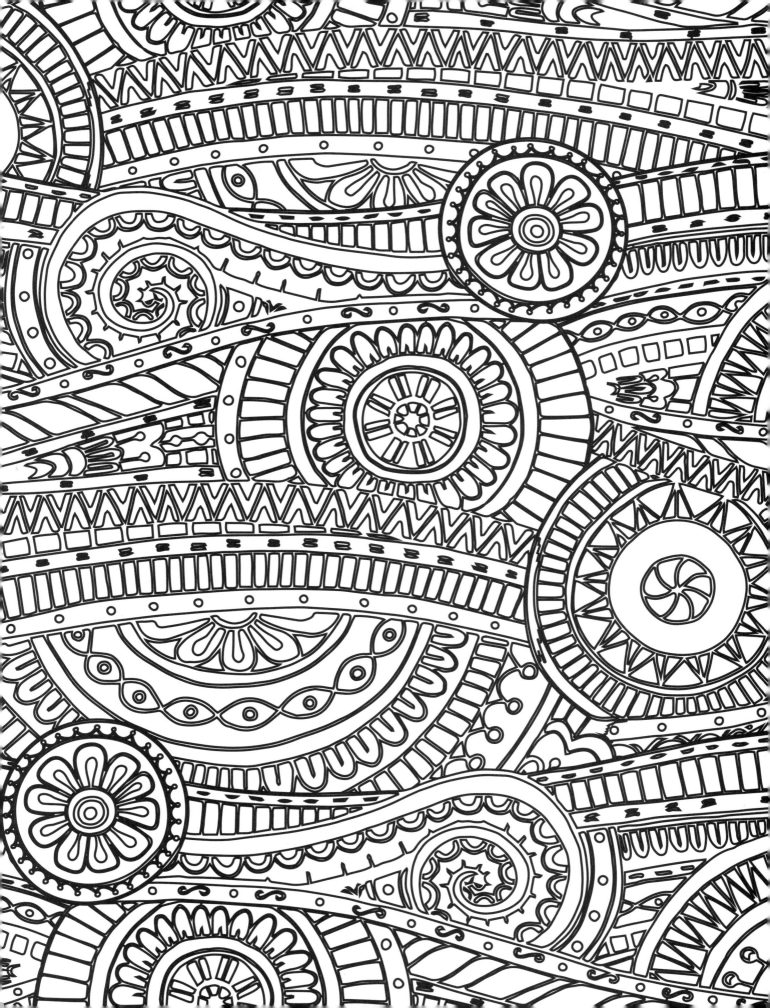

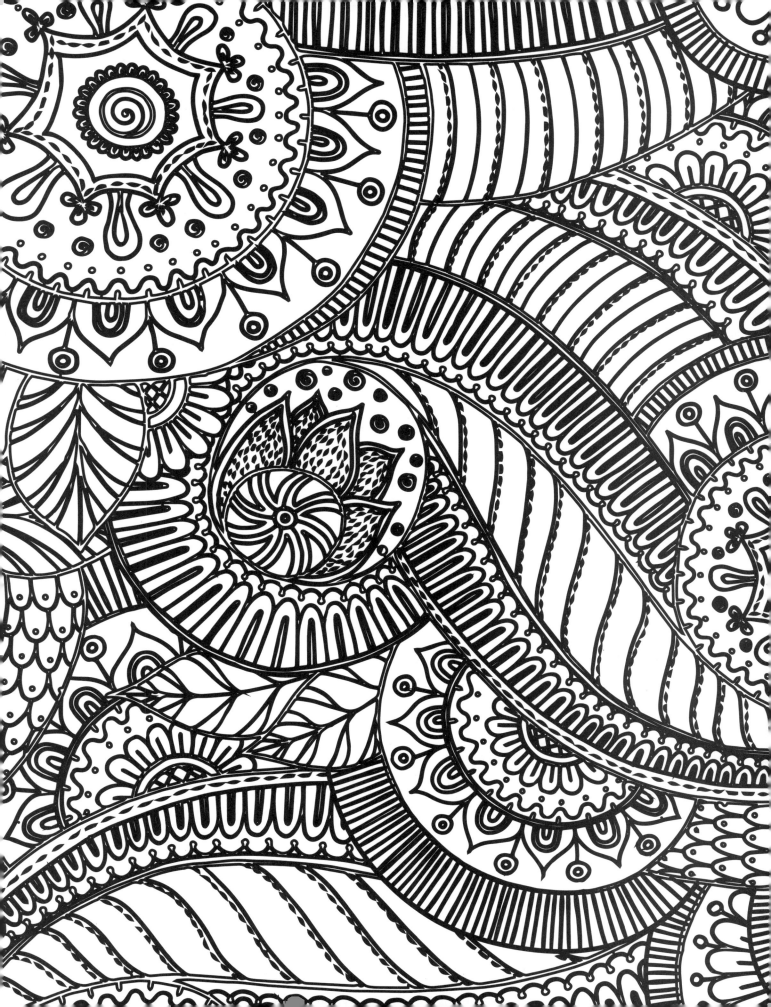

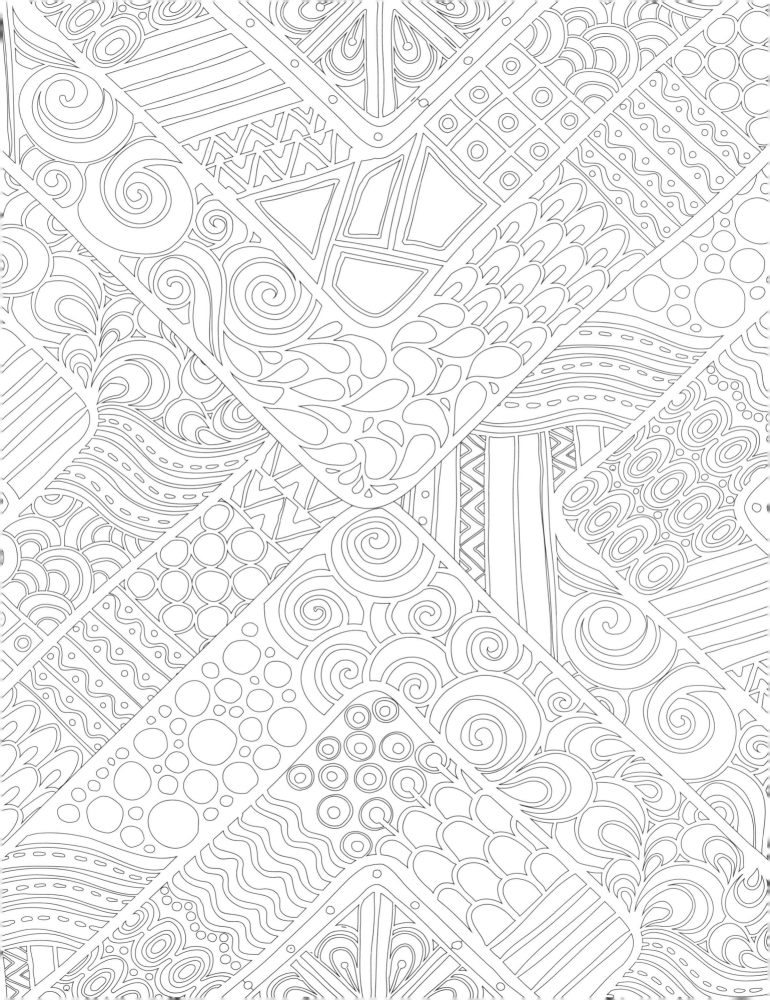

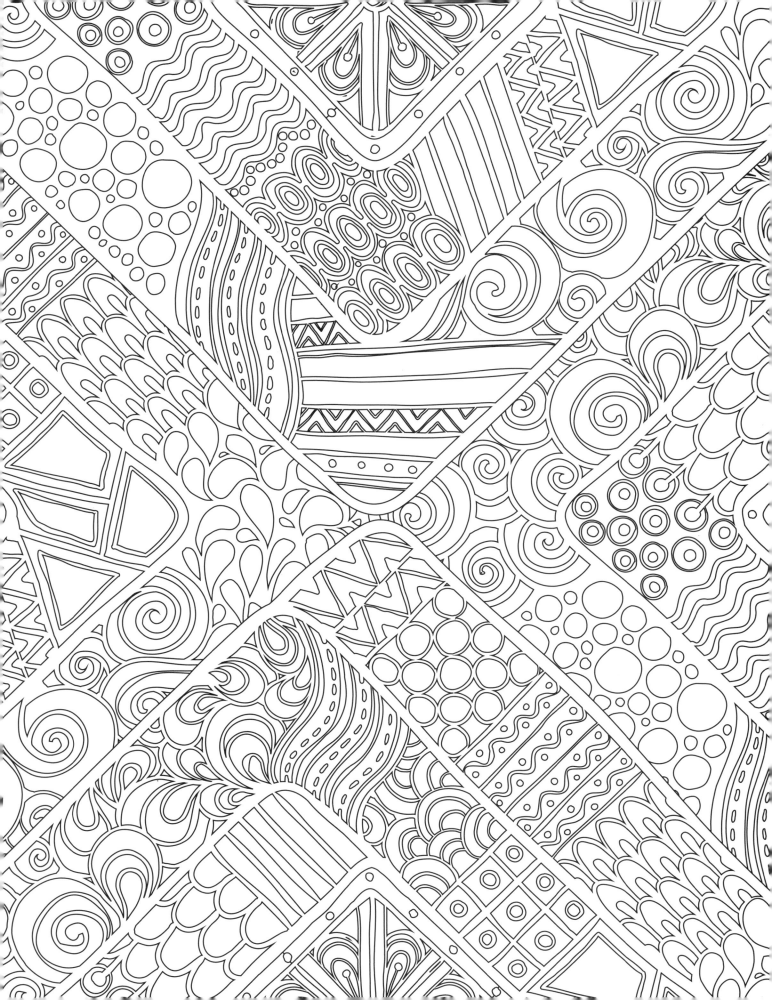

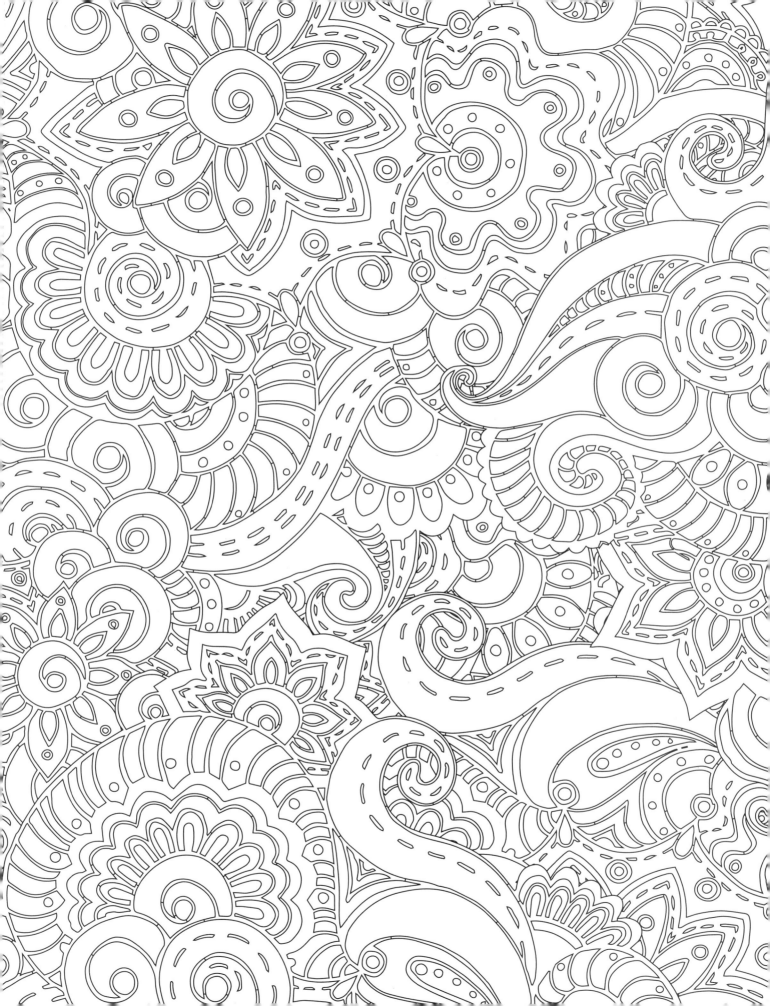

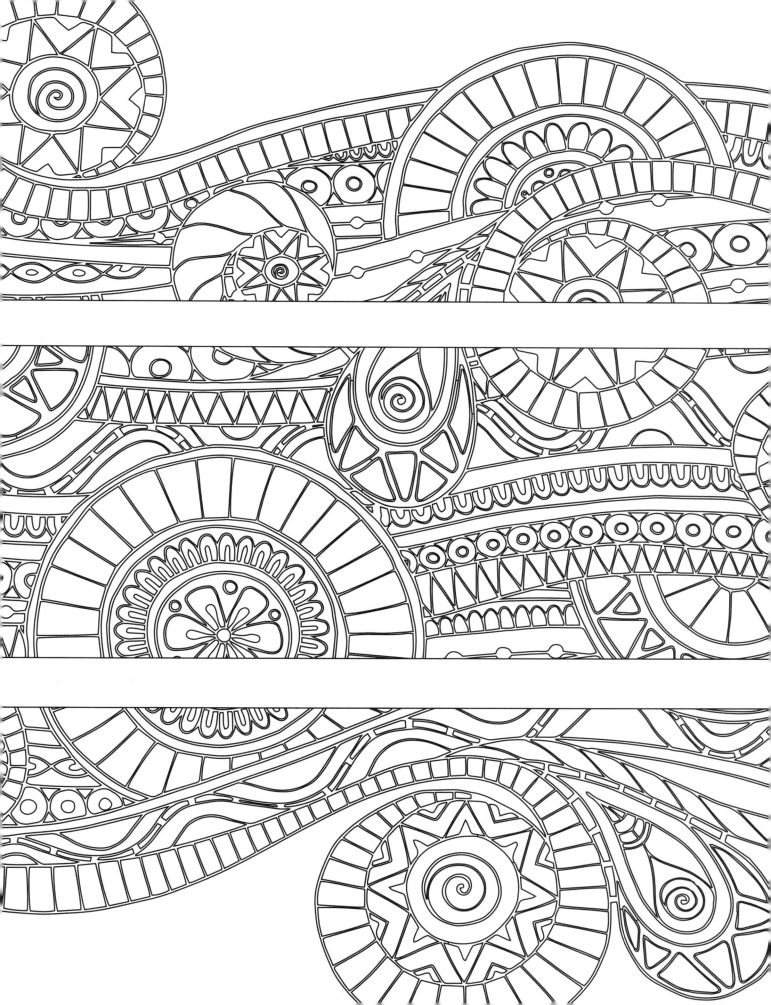

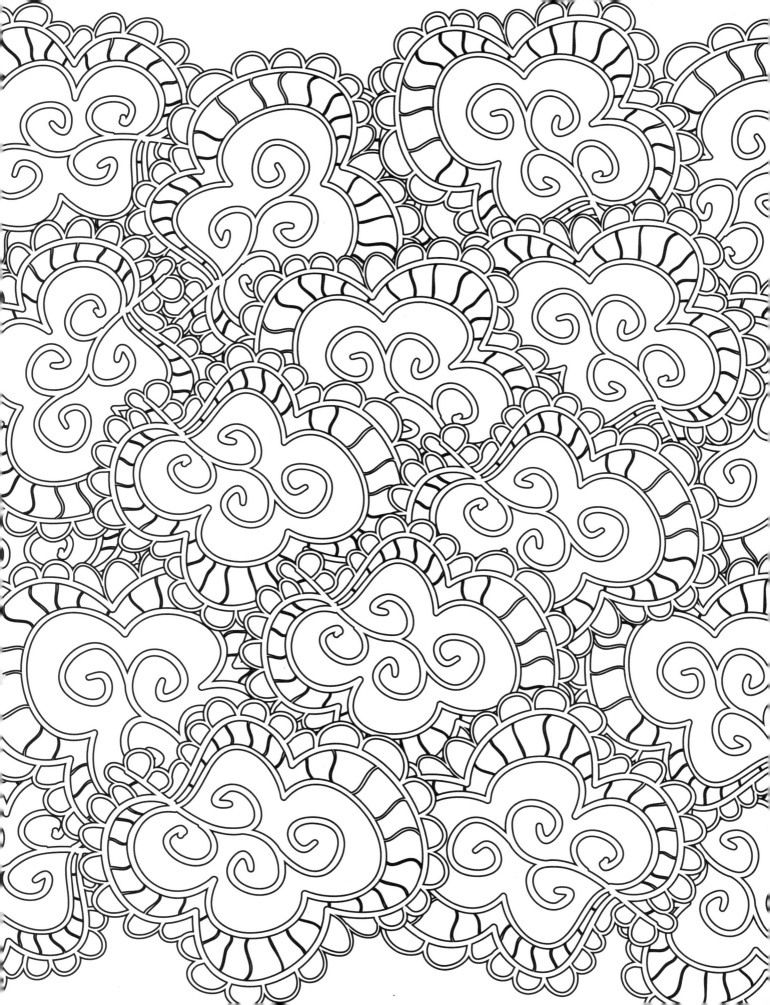

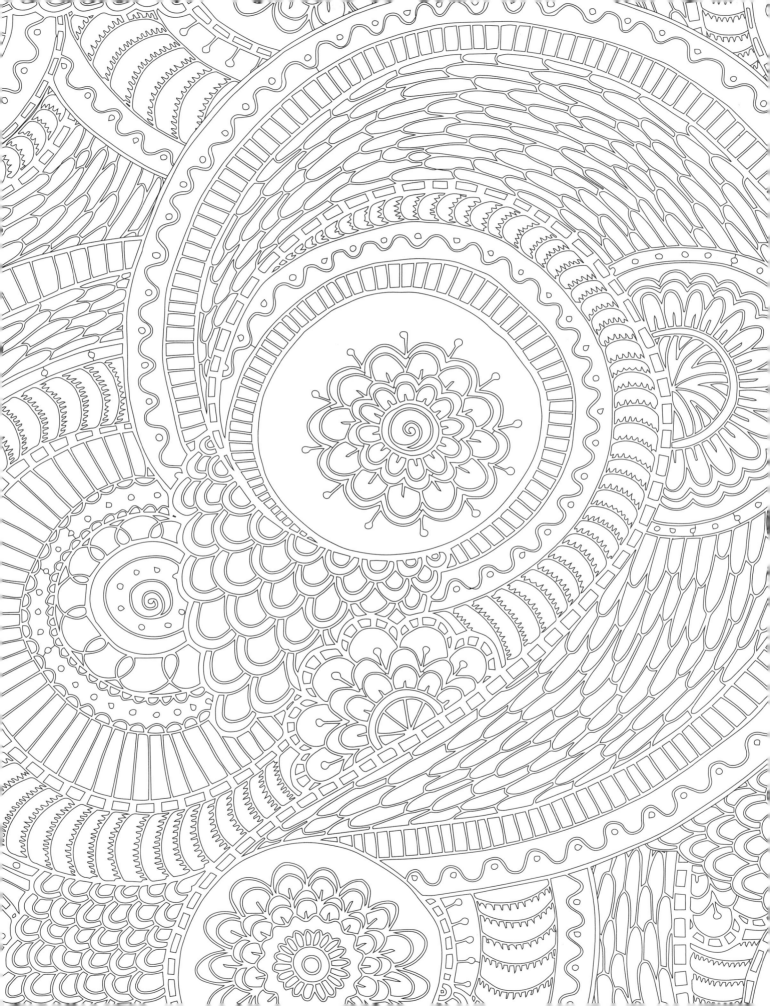

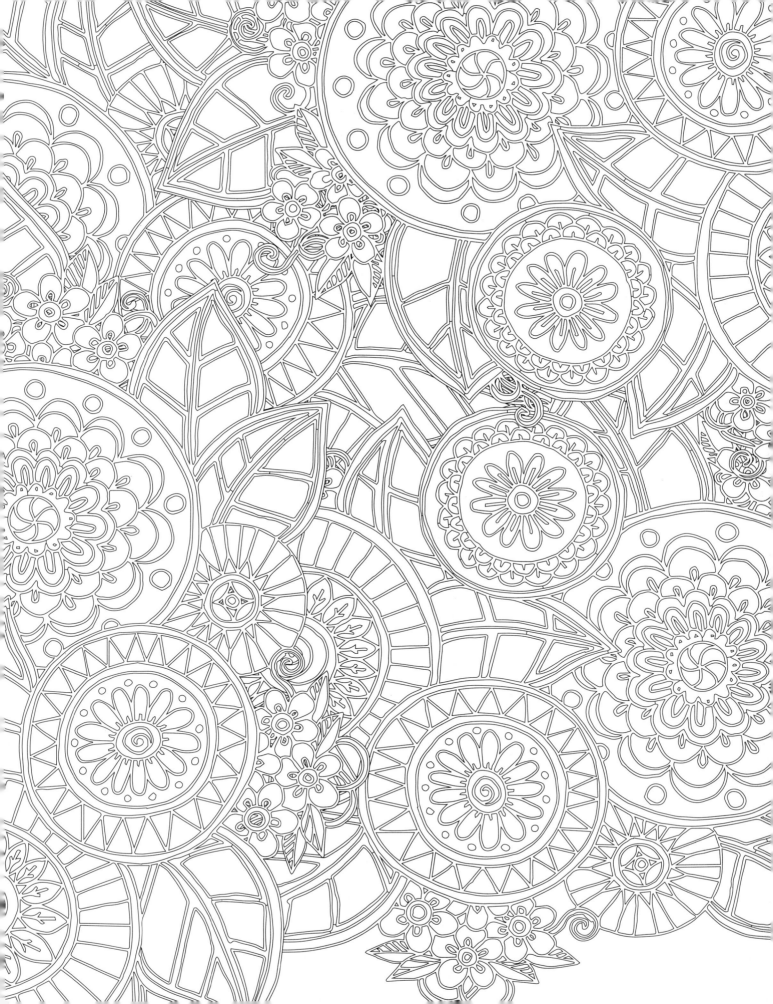

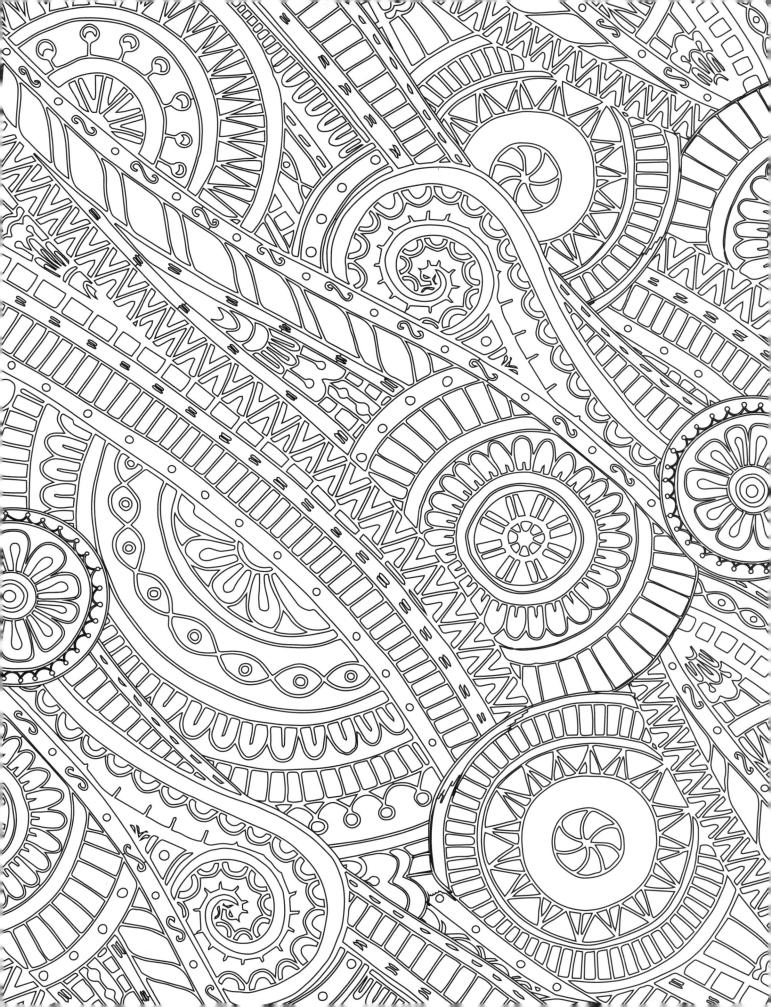

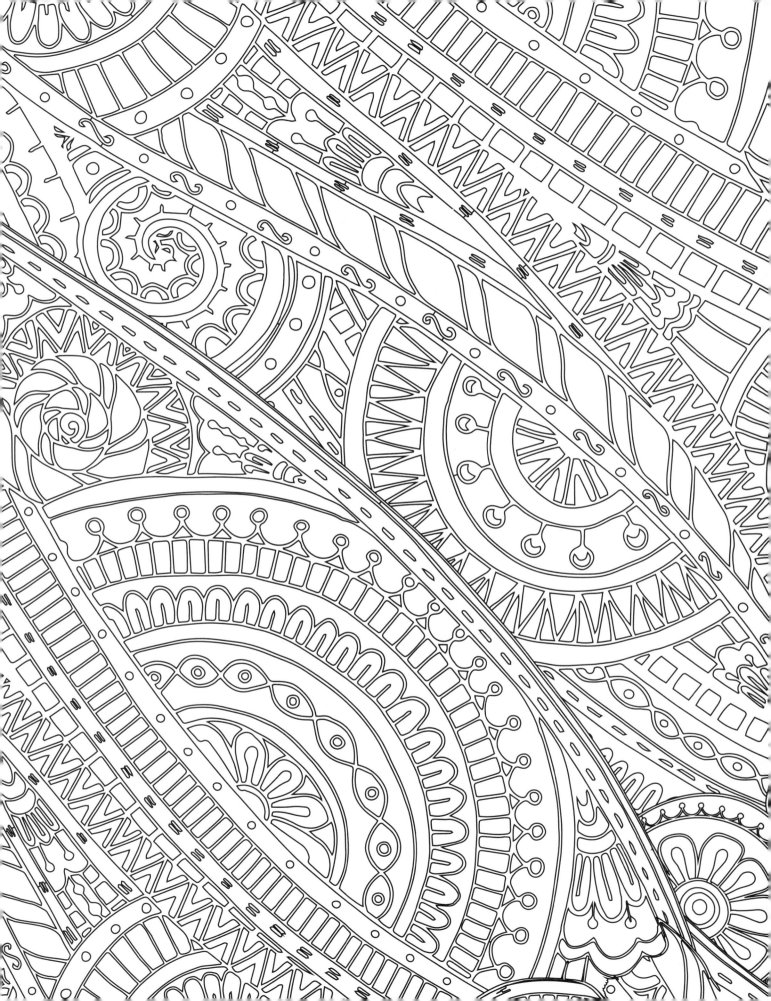

Color Bars

Use these bars to test your coloring medium and palette. Don't be afraid to try unique color combinations!

Color Bars

Color Bars

Color Bars